A Design Manual

Fourth Edition

SHIRL BRAINARD

Artist/Educator

PEARSON

Prentice
Hall

Upper Saddle River, New Jersey 07458

Library of Congress Cataloging-in-Publication Data

Brainard, Shirl.
 A design manual / Shirl Brainard.—4th ed.
 p. cm.
 Includes bibliographical references and index.
 ISBN 0-13-193155-5
 1. Design. I. Title.
NK1510.B773 2006
745.4—dc22 2004063399

Editor-in-Chief: Sarah Touborg
Acquisitions Editor: Amber Mackey
Editorial Assistant: Keri Molinari
Executive Marketing Manager: Sheryl Adams
Director of Production & Manufacturing:
 Barbara Kittle
Managing Editor: Lisa Iarkowski
Production Editor: Jean Lapidus
Copy Editor: Stephen C. Hopkins
Manufacturing Manager: Nick Sklitsis
Prepress & Manufacturing Buyer: Sherry Lewis
Cover Design: Kiwi Design
Image Permission Coordinator: Nancy Seise
Compositor: Wee Design/Pine Tree Composition, Inc.
Printer/Binder: Courier Companies, Inc./Stoughton
Cover Printer: Coral Graphics

Credits and acknowledgments borrowed from other sources and reproduced, with permission, in this textbook appear on appropriate page within text.

Pearson Education LTD.
Pearson Education Singapore, Pte. Ltd
Pearson Education, Canada, Ltd
Pearson Education—Japan

Pearson Education Australia PTY, Limited
Pearson Education North Asia Ltd
Pearson Educación de Mexico, S.A. de C.V.
Pearson Education Malaysia, Pte. Ltd

10 9 8 7
0-13-193155-5

Dedication
To Evan, Kelly, Alyssa, Kristyn, and Hannah.
And to Ilona, Mark, Cara, and Mike.
And to all my fellow artists and friends.

Contents

Preface

Many people want to be an artist when they grow up.

I consider myself very lucky. As a retired teacher of design and color theory, I can now wake up in the morning thinking about a painting to finish or one to begin. As I paint, I practice the design principles in this book. I am now an artist, but, thankfully, not totally grown-up!

With every revision of this book, I have understood how we all must progress and mature with our thinking, our concepts, our perceptions. What I practice now as a painter, I either didn't know or didn't believe when I was younger. I know now that education is a never-ending process . . . one of building information, keeping that information tucked away in some "file drawer" of our brain, and then pulling it out and looking at it anew. And perhaps then having an "Ah ha!" moment.

My mission with this book is to continue teaching and to offer some very basic contributions about design: basic knowledge for the student designer to build on.

I use many illustrations of everyday objects because understanding design is also the seeing of design. My confirmed belief is that students should become acquainted with the designers at work in their field today. And I also believe students have a right to see their instructor's work. While we should look at the masters of art history, we definitely need to remember that some of those in the field of design today will be the next generation of masters.

ACKNOWLEDGMENTS

Fortunately, I'm making art in an extremely energetic art community. I am so grateful to my fellow artists and colleagues, who not only willingly gave their work for this edition but also gave me personal support, sharing their knowledge of diverse fields. They often pointed me in helpful directions. My son Evan Brainard contributed sound advice and his viewpoints from the world of three-dimensional design. Artist Mark E. Mehaffey, artist/writer Wes Pulkka, and artist, teacher, and friend Jim Ferguson gave me some creative ideas. I thank the reviewers of my last textbook for their views and comments. To the museums, galleries, and private companies who gave me reproductions and who helped me find particular artists—a big thank you. I thank the followings reviewers for their helpful suggestions:

Alisa Fox of Ivy Technical State College, IN; Stacy Leeman of Columbus State Community College, OH; Susan Copas of Seward County Community College, KS; Jennifer Clevenger of Radford University, VA; Joan C. Balster of Gloucester Community College, NJ, and Gina Reynoso of Columbus State Community College, OH.

And, finally, to my editors Kimberly Chastain, Amber Mackey, and Jean Lapidus . . . what would I have done without their shoulders to cry on? Thank you.

Shirl Brainard

1

What Design Is

- ◆ **The Design Encounter**
- ◆ **What Is Design Supposed to Mean?**
- ◆ **Do All Designs Have Them?**
- ◆ **Theory**
- ◆ **This Is What *We'll* Do!**

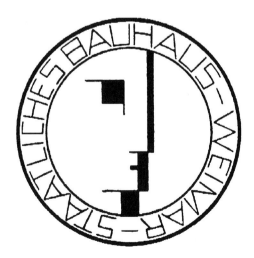

◆ The Design Encounter

We are going to explore the fundamental concepts of DESIGN. This book is, in fact, "designed" as "user-friendly," and the information in it is presented in a direct, conversational manner. And because design is all around us in our lives, some illustrations in this text are familiar objects.

Many related studies are connected with design, such as drawing, rendering techniques, or art history, but here we are concerned with ONLY the essence—or skeleton—of DESIGN. Other input and skills *can* and *should* be used to expand and elaborate upon this essence.

The content of this presentation will make us think about and explore ways of approaching our work in the design field.

Design concepts are not new. The Greeks had design standards some 2,000 years ago. Da Vinci made notes on design on many of his innumerable sketches. But the credit for analyzing various forms and structuring our basis for design theory goes to the Bauhaus, a school started in Dessau, Germany, in 1919 by Walter Gropius, an architect. He brought together a group of artisans with various training to lay the groundwork and to teach at this innovative and—eventually—influential school. The main concern of this school was to blend art with industry. Craftsmanship was of prime importance, but so were beauty and function. In formulating this bond, certain criteria emerged that were found to be in all of the classical arts. These criteria were isolated, discussed, and written about. All of the arts shared these standards, which have become the designer's visual vocabulary and circulating terminology over the years.

1◆1

The logo of the Bauhaus was considered "modern."

It's interesting to note that many of the practices that were routine at the Bauhaus are being reintroduced at some of the leading design and architectural schools internationally.

◆ What Is Design Supposed to Mean?

A **design** is a creative endeavor to solve a problem. A design is the end result—what you have when the problem is solved. It *is* the solution. **Composition** is the *way* the components, parts, or elements are used or arranged to reach the solution. A design *has* composition.

The very ACT of designing is COMPOSING. Design differs from math or any exacting science because there may be many solutions to a given problem, and that is the challenge (and fun) for the designer.

Design is all around us. We often say that something is well designed, especially if it *functions* well. We understand and are aware of new designs in cars, clothing, and home furnishings, but look around you. The parts that make up these common designs are in nearly everything we know, whether designed by man or nature. These parts or components we call **ELEMENTS: LINE—SHAPE—TEXTURE—VALUE—COLOR**—in a SPACE.

The *ways* these parts are used to compose the design are called **PRINCIPLES**. These principles are: SPACE DIVISION—BALANCE—UNITY—and EMPHASIS. We have to remember as we start this exploration about design that we are not talking about what "art" is. We are speaking about design. Many forms are well designed but they are not art. An example of this is a refrigerator—a refrigerator is a design, but it is not considered art.

◆ Do All Designs Have Them?

Think about the elements: SPACE, SHAPE, LINE, TEXTURE, VALUE, COLOR.

Do buildings have them?
Does a tree have them?
Does a painting have them?
Did your dinner last night have them?
ALL DESIGNS HAVE THEM.

It is easy to agree as we look at different things that, yes, all designs have these parts or elements.

◆ Theory

The study of design is a theoretical study. As in many theoretical studies, the theory and the result of the

practiced theory may be a contradiction! What is a theory? A **theory** is the examination of information, often through a nonscientific analysis. From the information studied, a plausible statement is made—an assumption. I am sure you have heard the statement that a certain idea "is fine in theory, but it doesn't work in practice."

Some time ago there was an article in a newspaper about an airplane powered by microwaves. It was amusing because the plane only flew for a few minutes, but "in theory" it was supposed to be able to fly forever.

The THEORY of design is that if you know the elements and principles of design—*voilà! Magic!* We can design!

However, it takes some forethought and planning. We must approach our ideas (or theories) of design in a systematic way, first things first. I have read design texts that give information about HOW to arrange the parts of a design, before students can identify the parts.

◆ This Is What *We'll* Do!

We'll begin at the beginning. We'll first look at the different design fields and then what our responsibility is in our role as designers. To clarify the process of designing, we'll use the analogy of baking a cake . . . not from a boxed cake mix . . . but an honest-to-goodness cake from scratch! First we gather the ingredients (the ELEMENTS), then we assemble the ingredients and

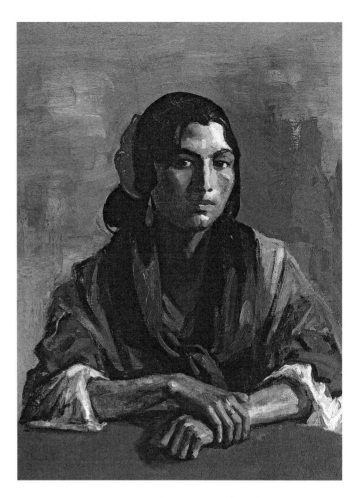

1–3

Robert Henri, SPANISH GYPSY. 1923. Oil on canvas. 32″ × 26″. Private collection.
Courtesy of Owings-Dewey Fine Art, Santa Fe, New Mexico.

bake the cake using the instructions (the PRINCIPLES). The kind of cake we bake will depend on both factors, as do designs. A memorable artist and teacher said: "There is a certain common sense in procedure which may be basic to all." Robert Henri spoke those words and they are as relevant today as when he spoke them to his students.

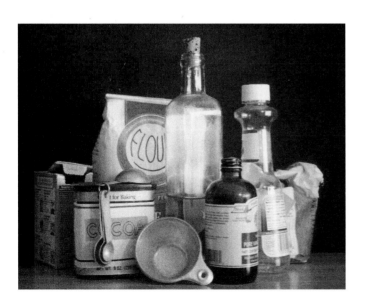

1–2

Ingredients for one kind of "scratch" (not in a box!) cake.
S. Brainard, Photo.

2

The Design Scene

◆ Kinds of Design

There are many kinds of design under the "Design Umbrella." If we look around us with a "new" eye, we see that *everything* that affects our lives was designed by *somebody*.

Design is basically classified into four categories:

1 ◆ FUNCTIONAL DESIGN includes the things in our lives we deem necessary. They *function* or do a task for us. Product design and structural design are included in this category. Product design is the most familiar . . . our automobiles transport us, electronics may be in the equipment we used at our jobs, our clothing covers us and keeps us warm or cool, and a can opener opens our cans. One furniture company has even redesigned one basic office chair in three sizes to accommodate our "growing" workers. Additionally, our homes are "architectural" or "structural" designs, and someone designs the structural steel that is the skeleton of many buildings.

2◆1

Our culture considers a refrigerator a "necessity."

2◆2

Both a product and a functional design, a car is expected to operate reliably. *S. Brainard, Photo.*

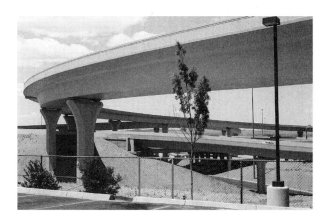

2◆3

The "BIG-I" interchange between two state freeways, Albuquerque, NM. Functional design. *S. Brainard, Photo.*

2 ◆ GRAPHIC DESIGN is also functional. It is a *visual* design meant to attract the eye to a product, to advertise or to give information for commercial purposes. Graphic designs include advertisements on TV, magazine displays, or logos that identify businesses or sports teams or sporting events, such as the five colored rings for the Olympics (see Figure 1–1).

2◆4

This logo is an example of graphic design. It advertises the studio and identifies the work of the "restoration of ceramic art and antiquities." *Source: Andy Goldschmidt. Courtesy of Andy Goldschmidt.*

3 ◆ ENVIRONMENTAL DESIGN is also functional, but deals with the OUTDOORS. Such design is inhabited by people or animals and includes public parks and gardens, zoos, and even our private residential landscapes. It also includes areas such as highways or median strips.

Usually the natural environment influences the type of design, as in the American Southwest, where lack of abundant water or rainfall necessitates "xeriscaping" (from the Greek, *xeri*, meaning "no water"). Gardens there will differ greatly from those along coastal areas, like Seattle or San Francisco, where reliable rainfall as well as water vapor creates lush plant growth.

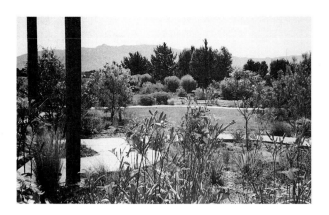

2•5

"Master Gardeners" created this xeriscaped garden, Sandoval County, NM. *S. Brainard, Photo.*

4 ♦ NONFUNCTIONAL DESIGN encompasses a wide range of decorative arts, including the making of stained or etched glass, jewelry, fine paintings, hand-carved furniture, and so forth. It is usually considered nonfunctional, because it satisfies more of an emotional or aesthetic need than a practical need. A glass in a door frame does not have to be etched. You don't have to have a tie with your shirt. It serves *no functional* purpose.

So why are some things designed to satisfy our aesthetic needs? Do we *need* beauty to survive? It is believed that we humans would not have evolved to our current level if we had not considered these inherent needs. Beauty enhances the quality of our lives. True, beauty is also in the eye of the beholder, and what

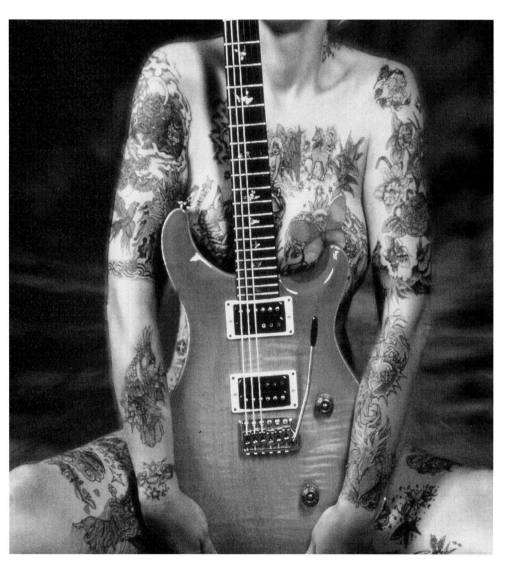

2•6

Tattoos are a mark of beauty for some people. *SuperStock, Inc.*

beauty is to one culture may not be beauty to another. But since early man, we have decorated ourselves and our environment. This is why some of these designs will overlap—be utilitarian but also attractive, like dinnerware; or be completely nonfunctional but well crafted, like a piece of jewelry. A house may be designed to fit "around" something in the environment—like a long but very narrow lot, or a boulder, or a tree—but will still be a safe, functional yet beautiful structure.

Louis Sullivan, an architect, said, "Form ever follows function," which means that the best design solution will follow the primary need of the problem. So, you see, the form of the building will conform to the problems of the environment, as ski clothing is designed to conform to the physical needs of the athlete as well as climatic conditions of the sport. Have you ever wondered who put the first handle on a vessel and made it become a "cup"? And think about how that cup handle has evolved to become a handle on a "mug." Most cups and mugs are now easier to hold. Did you know that antique cups had small handles for the main reason of propriety only? But some things will just be "pretty," with no reason to be otherwise. . . just because we humans *need* pretty things, like the ribbon bow on a gift.

◆ The Role of the Designer

It's important to know the role the designer must play. Designers today, in any field, may have to deal with many issues. One prevalent concern is that someone else may have an idea which the designer must implement, whether it's appealing to his or her creative nature or not. The designer may have their own office with its business practices, or may work for a corporation or collaborate with other designers in industry, marketing, and even manufacturing.

Different kinds of designs have different purposes, as we have discussed. It may be the intention of the fine artist to make social comment through a work of art. This may or may not be a positive, "pretty," or **aesthetic** comment. It is, however, the **content**, and this message was the **intent** of the artist. The viewer may indeed sense that feelings or emotions have been exploited, or even violated. That is, perhaps, exactly what the designer intended. The designer wanted the viewer to be shocked at what he or she saw and felt. If so, the designer was *successful!* Another artist may want the viewer to experience an upbeat mood, a feeling of lightness, warmth, or happiness. The design may

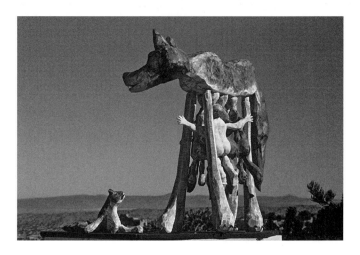

2·7

Roger Evans, ENDANGERED SPECIES. Acrylics on wood. 26" H × 26" W × 8" D. An environmental social statement. *Source: Roger Evans. Courtesy: Roger Evans.*

be successful in extracting that response from the viewer—or the viewer may not give it a second look.

In the first chapter we talked about the problems of the designer. While the fine artist may face the "problems" of mood or color as his or her objective, the designer of refrigerators has the problem of making the viewer stop, look, and OPEN the refrigerator door, making an evaluation about how this product would work in his or her kitchen. Then the viewer may consider purchasing the product. The role of any functional designer is more restricted than that of the nonfunctional designer. There are very specific messages—or content—directed to often very specific audiences. For instance, adults buy refrigerators, so that design message is not directed to children. Sometimes advertising is directed to children, so that they may coerce parents into buying a product. Sometimes communicating exclusive information is the primary responsibility of the graphic designer. This is the CONTENT of the work. The INTENT is the idea of the problem and its solution.

Designers must also be **original**. A friend told me that when he was in college, his teacher replied when he said he had no new subject to paint, "Yes, everything has been done, but not by you." This is so true. But beginning artists are often intimidated by this concept. So they hope that a "new" subject will appear magically for them to depict. There really are no new images or even new ideas! What may be new, however, are attitudes, tools, or media. Even the basic tenets of design and its components do not change . . . but the terminology (a "tool" of communication) may! So, even though an

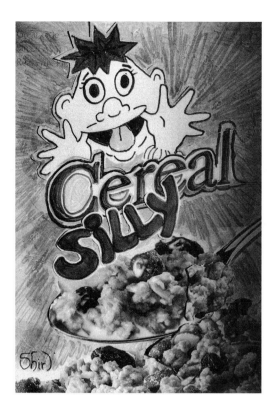

2•8

A graphic design advertises a product: cereal, geared toward catching a child's eye. *S. Brainard, Photo.*

2•9

Vebjorn Sand, THE LEONARDO BRIDGE PROJECT, Oslo. Currently a global project to build Leonardo bridges around the world as a tribute to Leonardo da Vinci and as a goodwill art project. This is an example of good design always being good design. *Brickfish Creative Services. Terje Johannsen, Photo.*

2•10

Original Leonardo da Vinci drawing with codex of Ponte da Pera a Gosstrantjnopoli bridge. Sketched in 1502 for Sultan Bajazet II of Constantinople. *Brickfish Creative Services.*

artist may be using an image or content that has been used for centuries, the way that idea or image is presented is what is new, creative, and original.

An example of using an "old" design is artist Vebjorn Sand's adaptation of a bridge designed by Leonardo da Vinci. The bridge proves that GOOD design is everlasting.

A version of "redesign," from an article in a contemporary design magazine, tells of a "cooky-shape" contest. YES! Cookies! The winners were a cookie with a slit to enable it to sit on the edge of a cup, and a long cookie to be used as a stirrer—a "dunking" cookie!

Artist Eugène Delacroix said, "What moves men of genius or rather what inspires their work, is not new ideas, but their obsession with the idea that what has already been said is still not enough."

◆ Are You Already a Designer?

Each of us gets up every morning, looks in the mirror, and asks: What am I going to do today? How am I going to function? Am I a businessperson sitting in ex-ecutive meetings most of the day? Am I a college student going to classes all day? Am I getting married? Will I jog before I do anything else?

What we decide to do will determine our selection of the clothes we will wear. We will also probably choose clothes that we think look well on us, color-wise and stylewise. We dress according to the chosen function for that day, and we try to look our best while doing it. We even think about how our hair should be

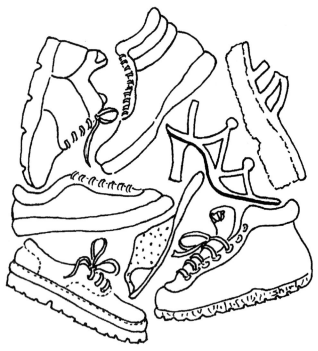

2•11

Line drawing of shoes. What you will be doing will influence your choice of shoes to wear.

arranged so that it best complements our features. We try, then, to present ourselves as a package, a total, a whole. We are the result of our clothes, hair, makeup, colors, and the like. We design *ourselves* every day. Yes, we are already designers.

You have been introduced to:

DESIGN
COMPOSITION
ELEMENTS
PRINCIPLES

Do you remember the differences among these concepts?

The parts: SPACE SHAPE LINE TEXTURE VALUE COLOR are *composed by using* SPACE DIVISION BALANCE UNITY EMPHASIS = *THE DESIGN!*

On the following pages, you will learn to identify the ELEMENTS in a SPACE and see how the PRINCIPLES have been used to compose or finalize the DESIGN.

◆ Let's Think About Design

Can some areas of design overlap? Can you determine which kind of design are involved in making the following?

Bathtubs	Pots and pans
Earrings	Greeting cards
Chairs	Nuts and bolts
Ships	Tablecloths
Skooters	Plates and cups
Textiles	Wallpaper
Vases	Hair ornaments
Bookcovers	Calendars

Which items can be functional as well as decorative? What one would YOU like to design?

Do you understand how the other design disciplines are connected with your design?

Keyword to remember: SOLUTION.

◆ Review

design ◆ A visual, creative solution to a functional or decorative problem.

composition ◆ The way the parts are arranged.

elements ◆ The parts, or components, of a design.

principles ◆ The ways the parts or elements are used, arranged, or manipulated to create the composition of the design; how to use the parts.

theory ◆ The examination of information that often ends in a plausible assumption or conclusion.

functional design ◆ Design that is utilitarian; necessary.

product design ◆ The design of necessary, functional items in a society.

graphic design ◆ Visual communication design for commercial purposes.

environmental design ◆ Functional designs considering natural surroundings.

nonfunctional design ◆ Design that is decorative or aesthetic. It is not strictly necessary to our functioning as a culture.

aesthetic ◆ A personal response to what we consider beautiful, often based on cultural or educational experience.

content ◆ The message created by the artist. May be functional for consumer purposes; iconography.

intent ◆ What the designer or artist intended with the design; may not have content or message.

original ◆ A primary, inventive form of producing an idea, method, performance, etc.

3

Space

- ◆ **Kinds of Space**
- ◆ **Let's Think About Space . . .**
- ◆ **What Can You Do with Space?**
- ◆ **Can You Identify . . .?**
- ◆ **Review**

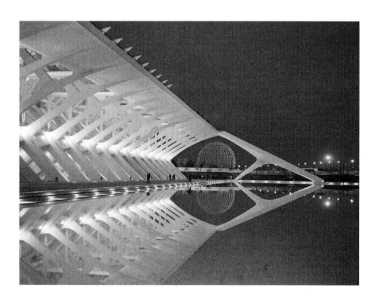

Before we begin looking at the parts, or ELEMENTS, of design, let's remember that we're studying some basic guidelines to help us look at what we see around us with an objective, more informed view.

◆ Kinds of Space

Psychologist Rollo May said: "The first step in the creative process is "Encounter"—the seeing/meeting/perceiving a problem to be solved in a creative way."

SPACE is the first thing we encounter.

Technically, space is not considered an element, but it is so essential to understanding the concept of design that I would like to think of it as a part of our whole.

The page before this one is empty. EMPTY, NOTHING, **negative**, SPACE. **Space** is where we start to solve our design problem. Even if we are designing a **three-dimensional** building or a sculpture with height, width, depth, and volume (or weight), we would use paper for planning our design. That paper is a **two-dimensional** space, having only width and height.

This two-dimensional space is called our **working space**. It gives us an idea where our limitations are—our boundaries. This working space often reflects what is called the **actual space**. The actual space may be a build-

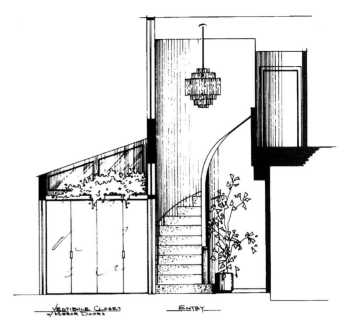

3◆2

The three-dimensional space is planned on a two-dimensional space. *Douglas Richey. A.S.I.D. Interior Design.*

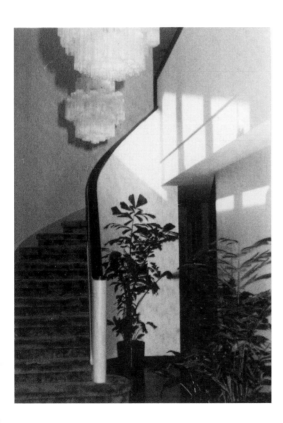

3◆1

Three-dimensional space (a foyer in a private home). *Douglas Richey. A.S.I.D. Interior Design.*

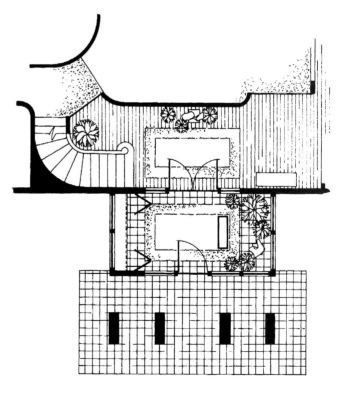

3◆3

Floor design of foyer space (see Fig. 3.2), done on a two-dimensional space. *Courtesy: Douglas Richey, A.S.I.D. Interior Design.*

ing lot for which an architect will design a house, several city blocks that will become a city mall, a portion of a magazine page where an advertisement may appear, or an empty canvas that will become a painting.

In order for us to fit our ideas realistically onto this space, our ideas have to conform to the space we have. If we are visual artists—such as painters or printmakers—we can pretty well choose our own space and create our own problem to solve: What do I put on this space now? But if we were that city planner with those city blocks, we must plan for *that* given space.

In this electronic world we think all problems are solved on the computer. In a recent article about the very innovative Santiago Calatrava, who designs sculptural-like train stations, air terminals, and bridges, it's interesting to note that he does all of his initial designs by drawing on paper. The specifications are worked out later on a computer.

The two-dimensional painter, or perhaps the architect will now be confronted by a different kind of space: the ILLUSION of DEPTH or DISTANCE. Because it is something to contend with, we'll be introduced to **pictoral space**: that is, the presentation of a foreground, a middle ground, and a background. We'll look at the most basic and familiar aspects of pictorial space, of "visual" distance. Leonardo da Vinci said that "perspective is the rational law by which experience confirms that all objects transmit their image to the eye in a pyramid of lines."

The usual solution of creating this "visual" distance is by using *linear perspective*, which is not a matter of design as much as a mechanical <u>DRAWING</u> technique. Basic to drawing perspective is the determination of the eye level in relation to the horizon and in relation to the subject. This determination is called the <u>horizon line</u>. A <u>vanishing point</u> is then established:

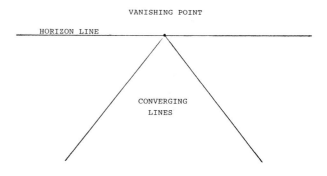

3•6

Depiction of da Vinci's Pyrapid.

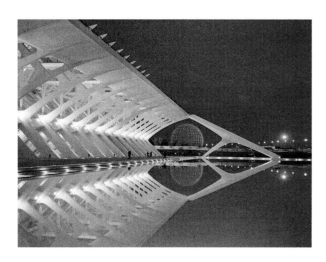

3•4

Santiago Calatrava, CUIDAD DE LAS ARTES, Valencia, Spain.
Jose Fuste Raga, Photo. Source: Corbis/Bettmann.

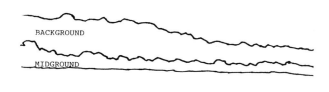

3•5

Pictorial space (or working space) usually depicts background, middle ground, and foreground, or variations of these three.

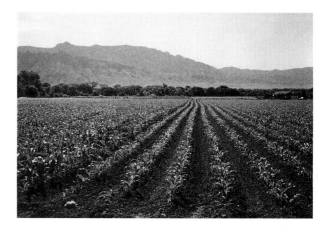

3•7

Cornfield shows how rows of corn visually converge at a vanishing point. *S. Brainard, Photo.*

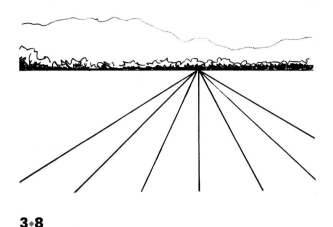

3·8

Diagram of 3-7.

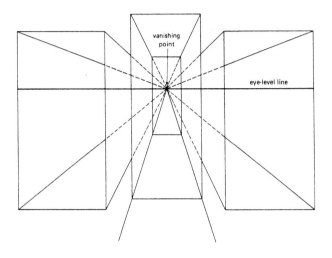

3·9

Diagram of one-point perspective. All horizontal lines converge at a vanishing point. Verticals remain perpendicular to bottom of space.

This is where subjects <u>APPEAR</u> to disappear into the distance. Depending on the number of subjects and their relative "sides," there MAY be multiple vanishing points.

Other ways to create the feeling of visual distance may include using <u>diminishing sizes</u>, overlapping shapes, changing values (see figure 6–7), or changing uses of color. More about these techniques will be addressed in our discussion of PRINCIPLES. In designing, we have help our eyes see what we want them to see.

With some designs we must plan ahead about HOW our <u>actual</u> space may be used. Do we need space for people to move about, such as in a mall or a garden?

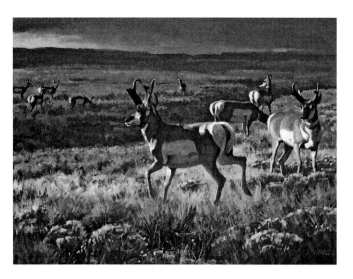

3·10

Dave Wade, A DISTANT THUNDER. Oil. 30" × 40". Overlapping and diminishing sizes of the pronghorn give the viewer an illusion of distance. *Source: Dave Wade. A Distant Thunder/Dave Wade.*

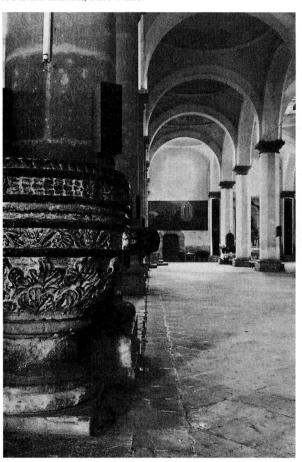

3·11

Lincoln Draper, BAPTISMAL FONT, CAPILLA REAL, Mexico. Platinum/palladium print. Value changes and almost converging horizontals convey to the viewer the depth of space. *Source: Lincoln Draper.*

Or how about moving around a sculpture? (see 14–A, B, C). Or how about a zoo? Animals must be able to move about in their space. Or consider a kinetic sculpture or a ride in an amusement park? And what about the TIME needed for any of these designs to be realized? Sometimes we must think about the CONCEPT of **time and motion**.

In PLANNING our designs for a given space, we need to know how much space we have . . . and what shape that space is.

The shape and direction of our space is called **format**. If that empty page at the beginning of this chapter is looked at in the usual way, or direction, the book is read, it has a **vertical format**. If you turn the book sideways, this empty page would have a **horizontal format**. Andy Warhol said, "I like painting on a square because you don't have to decide whether it should be longer-longer or shorter-shorter or longer-shorter; it's just a square."

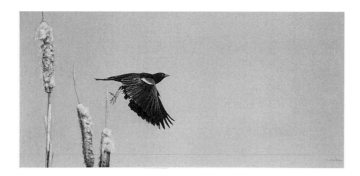

3•12

Sueellen Ross, TAKING FLIGHT, Mixed media. 12" × 28". The horizontal format and empty visual space allows the viewer to experience motion about to happen in a given time. *Courtesy: Sueellen Ross.*

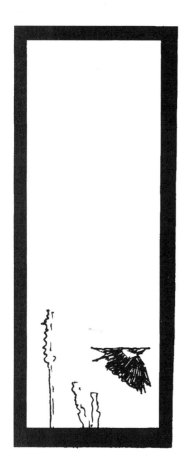

3•13

Illustration of TAKING FLIGHT by Shirl Brainard. *Source: Shirl Brainard.*

CORRALES
BOSQUE
GALLERY

3•14

Logos for Corrales Bosque Gallery, Corrales, NM. Both horizontal and vertical formats allows this logo to fit various advertisements, letterheads, brochures, etc. *Source: Corrales Bosque Gallery. Courtesy of the Corrales Bosque Gallery.*

3•15

Logos for Corrales Bosque Gallery, Corrales, NM. Both horizontal and vertical formats allows this logo to fit various advertisements, letterheads, brochures, etc. *Source: Corrales Bosque Gallery. Courtesy of the Corrales Bosque Gallery.*

First, we will talk about two-dimensional design only—that design that is ORGANIZED on a flat surface with only height and width.

◆ Let's Think About Space . . .

Why do we use a two-dimensional surface if we want to design a three-dimensional object?

What does FORMAT have to do with our design?

Is our working space ever our actual space? Give an example.

Why would a given or actual space affect our choice of FORMAT?

Would a "circular" format have a direction?

If you plan the arrangement of your furniture on a piece of paper representing your apartment, what *kind* of space is the paper? What *kind* of space is the apartment—or room, or house?

Can you depict a full three-dimensional scene on paper?

Does there ALWAYS have to be a horizon line in a painting?

Can you imagine the ACTUAL space for a zoo? Can you draw it?

Keyword to remember: SPACE—an empty (NEGATIVE) area where our design will fit.

◆ What Can You Do with Space?

What do you think your answer should be?

◆ Can You Identify . . .?

WHERE the vanishing point may be in figures 4–13, 12–8, and 14–1? *If* figure 3–12 had been on a format like figure 3–13, *how* would that have affected the viewer?

Can you identify these formats by direction or shape name?

3◆16

Various formats.

◆ Review

space ◆ An empty, negative area where our design will fit.

negative space ◆ Completely empty actual or working space.

two-dimensional space ◆ A flat space; having only height and width.

three-dimensional space ◆ Space having height, width, and depth.

actual space ◆ The real space we have to fill with our design. This space has definite dimensions.

working space ◆ The space that reflects the actual space. The two *may*, but not always, be the same space. This is the space we use to solve our design problem

format ◆ The shape and direction of our working or actual space. MAY BE HORIZONTAL, VERTICAL, ROUND, or the like.

pictorial space ◆ The illusion of depth or distance on a two-dimensional space.

perspective ◆ The drawing technique of creating the receding, diminishing, or vanishing objects of a three-dimensional nature on a two-dimensional surface.

time and motion ◆ In design, the planning for the ACTUAL space to be used in bodily movement, OR the anticipated illusion of movement in time.

4
Line

THIS IS A LINE

THIS IS A LINEAR SHAPE

4·1

Line and pencil.

◆ What Is a Line?

How do we describe a line? How does it differ from a shape? Can a line be a shape? Can a shape be a line? A **line** is a mark that is longer than it is wide and is seen because it differs in value or color from its background.

As small children, the first thing we draw on a piece of paper with a marker (or crayon, or pencil) is usually a squiggly line. What we experience then is the magic of seeing "something" appear on the paper.

A line is not usually thought of as a shape, but a shape can appear **linear**.

4·2

An example of linear shapes. *S. Brainard, Photo*

On the following pages, you will see different things that lines can do for us. Again, we use these all the time, but seldom do we think that it is a line being used.

◆ Kinds of Line

LINE AS CONTOUR. We know that in drawing, line can create shapes. As children we probably had our first coloring books to scribble in and to help us begin

identifying objects. The coloring books had simple objects drawn by using simple lines—outlines. That same "outline" is called a **contour line,** or a line that defines the outer edges of shapes. We use it constantly to begin our drawings.

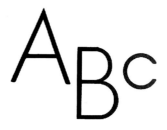

4·3

Wesley Pulkka, RECLINING NUDE. Pencil drawing.
Courtesy: Wesley Pulkka.

But, to quote again from Robert Henri, "In considering lines as a means of drawing, it is well to remember that the line practically does not exist in nature."

Contour lines are also often used in map design to show water depths or land contours—different elevations and shapes of land masses—as well as in architectural renderings and interior drawings to show the shape, size, and position of structures.

LINE AS A SYMBOL. How often when you letter or write do you *think* that you are only using lines? Yet the letter A is made of lines and yet acts as a symbol of communication. It is a symbol of the first letter in our alphabet. Our numbers, too, are made up of a combination of lines to create symbols that mean something to us.

ABc

4·4

Our alphabet is made up of lines—they become symbols.

4•5

Diana Stetson, SUMI INK ON ARCHES 90# HOTPRESS. Calligraphic symbols from the Japanese, Chinese, Sanskrit, and Eskimo languages.

Lines may be **symbolic** in other ways. The manner in which lines or linear shapes are positioned may portray certain sentiments or attitudes. Lines or figures lined up in a straight vertical way give us the feeling of alertness, dignity, even rigidity. Lines used in a horizontal way may make us feel more restful; a feeling of repose or quietude.

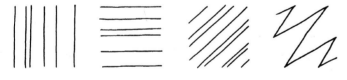

4•6

Symbolic lines that suggest motion.

Lines on a diagonal create a compromise between rigidity and repose—becoming more interesting than either the horizontal or the vertical. They are relaxed, but not lazy.

But POW! Diagonal lines can also be exciting, dangerous, and even sometimes confusing. These are dynamic but usually too forceful to use in abundance.

LINE AS DIRECTION. Linear shapes are familiar to those of us who drive. What do we know when we see this road sign (see figure 4–7)?

Again, it is a symbol, but one of direction and information. Lines can establish a sense of **direction** or

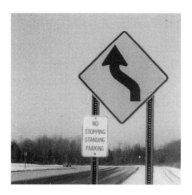

4•7

Road sign. *S. Brainard, photo.*

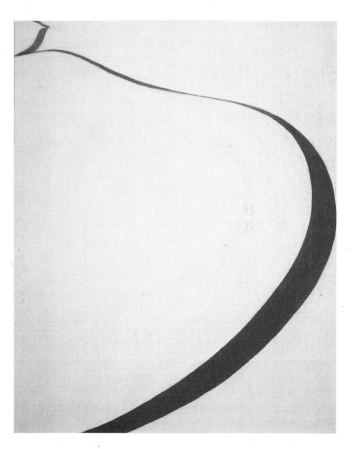

4•8

Georgia O'Keeffe, WINTER ROAD I. 1963. Oil on canvas, 22″ × 18″; framed, 22³/₁₆″ × 18¹/₄″. National Gallery of Art, Washington, DC. This painting of a road in winter looks like a line and also like the road sign. *Gift of The Georgia O'Keeffe Foundation. Copyright 1998 The Georgia O'Keeffe Foundation/Artists Rights Society (ARS), New York.*

movement within the given space. Think of a kite up in the sky with its tail weaving back and forth in the wind: Our eye sees movement. Think of a fence meandering across a field: Our eye *senses* movement.

LINE AS A BOUNDARY. A line also acts as a **boundary.** Any edges of two shapes that abut or share the same edge can create a visual line. And that line is, therefore, a boundary line separating the two shapes. Think of a fence separating two properties. If we could see it from the air, we would perceive a line instead of the fence itself.

4·9

A grid is an example of lines dividing a space into smaller spaces.

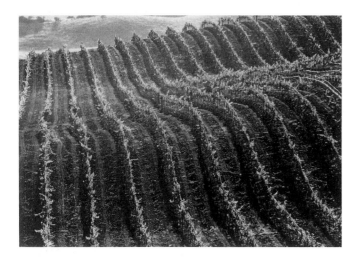

4·10

Rows of plantings, seen from the air, divide the space of the vineyards. *Max Aguilera-Hellweg, Photo, CHALONE VINEYARDS, Los Angeles, CA.*

IMPLIED LINE. Implied lines are lines that do not physically exist but are visually connected by the eye. An example is this broken line: _ _ _ _ _ _ _ _ _ _ _ _ _ _

The vacant or negative areas are still perceived by the eye and mind as filled in to complete the line—the implication of a total continual line

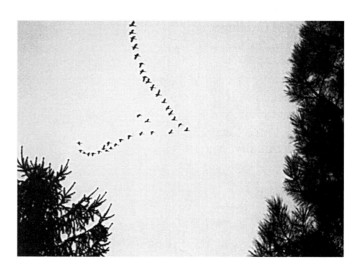

4·11

Geese in flight create an implied V-shaped line. *S. Brainard, Photo.*

LINE AS VALUE. When we draw black lines close together on a white surface, we are making a darker area relative to the white negative area. Fewer lines would give the visual illusion of a medium-shaded area, and we could control our "shading" process with the number of lines used.

LINE AS TEXTURE. If you pull out one of the hairs from your own head and hold it taut between the

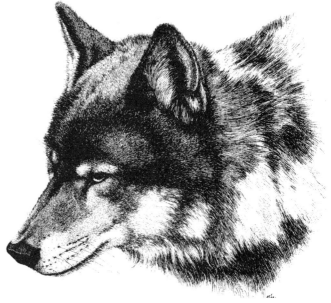

4·12

Claudia Nice, TIMBER WOLF. Ink drawing. The play of lines creates the texture of the wolf's coat. *Courtesy: Claudia Nice.*

thumb and forefinger of each hand, you see a line. Put millions of these lines together and you have hair—hair that can be kinky, curly, straight, permed, and going in many directions. It has the sensation of something you can touch or feel. To recreate this feeling of texture with line, you would have to study the hair or lines and watch the many different directions the hairs take individually. Many kinds of textures can be reproduced by the use of line.

◆ Let's Think About Line . . .

When was the last time you used a line—in *any* way? What was it?

Did you create a boundary?

Did you follow a street sign?

Did you divide some kind of space?

Did you fly a kite?

Did you write or add figures manually?

Did you draw in the sand with a stick?

Did you make some shapes?

Did you plan a house?

Did you sew (either with a machine or by hand)?

What else did you do?

Keyword to remember: LINE—a long, thin mark, or images that make you *think* of long, thin marks!

◆ What Can You Do with Lines?

You can make lines . . .

THIN

THICK

LONG

SHORT

VERTICAL

HORIZONTAL

CLOSE TOGETHER

FAR APART

DIAGONAL

ZIGZAG

CURVE . . . AND WHAT ELSE?

You can use lines to . . .

DIVIDE SPACE

MAKE SHAPES

MAKE SYMBOLS

DIRECT THE EYE

CREATE VALUE

CREATE TEXTURE

AND . . .?

LINE IS IMPORTANT!

◆ Can You Identify . . .?

Lines?

Linear shapes?

How this photo makes you feel?

WHY?

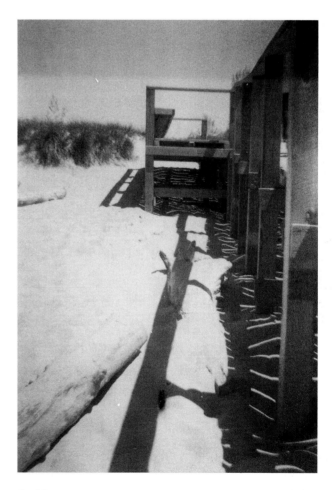

4·13

Holland Beach boardwalk. *S. Brainard, Photo.*

◆ Review

line ◆ A mark longer than it is wide and is seen because it differs in value, color, or texture from its background.

linear shape ◆ An elongated shape that reminds us of line.

contour line ◆ A line depicting the outer edge of a shape or group of shapes.

symbolic line ◆ A line or combination of lines that stands for, or reminds us of, something within our realm of knowledge.

directional line ◆ A line or lines that direct our visual attention in a specific direction.

boundary line ◆ A line that confines our visual attention. It may serve to separate areas.

implied line ◆ A perceived continuation of images or symbols that implies a line.

5

Shape

◆ What Is a Shape?

A **shape** is an image in space. This shape may or may not be recognizable. Babies see an undefined blur that changes to a face with color and with a voice that is eventually recognized as a sound that goes with this "shape."

Later, when we are older, someone gives us a crayon and some paper, and with lines we start to draw our small world (remember those lines in the last chapter?). We hook the lines together and they turn into shapes that become someone who is important to us—Mama, the cat, or "Jimmy" (an imaginary friend). To us, the shape we put on our paper is who or what we say it is. The *drawing* of Mama, however, is what becomes the subject of the day, not Mama herself. The family is proud of the drawing, and *voilá!* An artist is born! It does not matter that it is not an exact duplication, or even a near representation, of Mama; it is the essence or the symbolism that has become important.

It is hard for us to accept this symbolism. Why has Picasso's work been so difficult for people to accept? Because it is ugly? We have trouble with Picasso because his faces do not seem like faces we *know*. As we grow older, realistic or representational shapes seem to become more important to us than symbolism.

There is a paradox here.

As we enter the years of curiosity, experimentation, and rebellion, why don't we reject the *images* that are familiar to us in the same way we turn against other familiar things, like our dress, our behavior, or the food we eat? Why don't we experiment with images the way we experiment with other things in our new grown-up life? Instead, we cling to the traditional, to the familiar shapes of "things" we *know*.

"*Things*" are used as sources for kinds of shapes, and the original meaning of the "thing" is no longer as important as the found shape.

◆ Kinds of Shapes

This is a "rose." We know it as a "thing," an object we all recognize. We are now going to try and think of this rose as a **shape,** a source for other shapes, shapes in space.

The rose (an identifying name only) can be the source for many kinds of shapes that the design world puts into categories. One such category is **natural shapes**—shapes as we know them in their natural state, or from the world of nature. These are familiar to us. In other references, you may see them called organic or biomorphic shapes.

These shapes can be altered, simplified, distorted, enlarged, half-hidden . . . anything that changes them . . . and their subject may still be recognized; the essence remains. They are then called **abstracts,** since

5◆1

Kristyn Brainard, GRANDMA & ME. Colored ink drawing. (The author is on the right.)

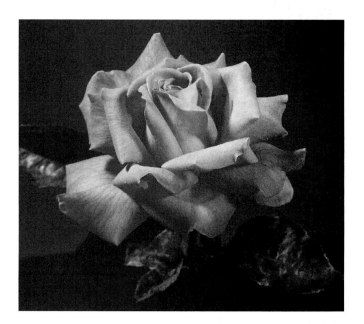

5◆2

"Chicago Peace" rose. Photo. A rose is a natural shape—or a shape found in nature. *Photographer: Goodman. Source: Jackson & Perkins. Photograph courtesy of Jackson & Perkins.*

5◆3

Artist unknown. Chinese paper cutting. This rose is seen as a rose but is not "realistic." It is slightly abstract. *Collection of the author.*

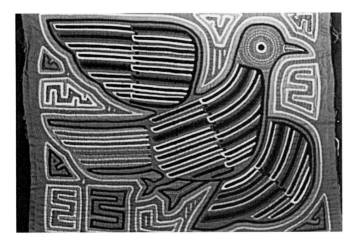

5◆4

Artist Unknown. The "mola" is an art form of reverse appliqué indigenous to the Cuna Indians of San Blas, Panama. This abstract shape of a bird uses geometric shapes. *Courtesy of S. Brainard.*

5◆5

Inlaid jewelry using geometric shapes. *Judith Young/Alan Edgar Jewelry. Source: Judith Young. Courtesy of Edgar/Young Jewelry.*

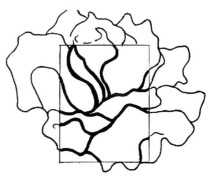

5◆6

The line drawing represents the rose. The portion shown is later enlarged.

they are "abstracted," or "pulled from" the original.

Pablo Picasso said "There is no abstract art—you must always start with something."

Sometimes circles, squares, and triangles are used to create an abstraction of a natural shape. These are called **geometric** shapes and are usually thought of as man-made shapes, being more precise and even than shapes in nature. Buildings, for instance, are usually designed from geometric shapes.

If we were to enlarge just one portion of our original shape, it would no longer be recognizable as a rose—just some weird shapes. These new shapes are often called invented, found, or **nonobjective** shapes. There is NO object, no symbol for us to identify: They are just shapes. Enlarging is not the only way to create nonobjective shapes. If you spill a liquid, for instance, it makes a shape. You cannot reproduce that shape by spilling that liquid again, but it could be copied and used as a shape.

Knowing the names or titles of different shapes helps you verbalize more precisely about your own work and makes you sound professional. It will help you to understand an author when you read; to understand other related material, such as videos, or lectures; or, when you visit an art gallery or museum, to identify kinds of art as abstract, nonrepresentational, or representational because of the shapes used.

5·7

The enlarged portion (turned in another direction) produces shapes that do not represent any object or shape. They have become nonobjective shapes.

5·8

Example of a nonobjective shape. *Source: S. Brainard.*

◆ Positive and Negative Shapes

When we place any of the shapes we have been discussing in our empty space (NEGATIVE SPACE), we call it a **positive shape.** The space left over is still negative space—there is nothing there.

If we place at least two shapes together in this space, touching or almost touching, we create an illusion of a third (or more) shape(s). This illusionary shape is called a **negative shape.** This is more often called the POSITIVE and the NEGATIVE GROUND.

Below is an example of the use of positive and negative shapes. What do you see? Do you see the faces or

5·9

What do you see?
Two faces? A vase?
Which is the negative?
Which is the positive?

do you see the vase? Which is the one you are supposed to see? Is there an answer to this question?

Betty Edwards said in *Drawing on the Right Side of the Brain,* "Usually it takes years of training to convince students, in the way experienced artists are convinced, that the negative spaces, bounded by the format, require the same degree of attention and care that the positive forms require."

◆ Let's Think About Shapes . . .

Produce all four kinds of shapes (natural, geometric, abstract, and nonobjective) from one source.

What kind of shape was the original source you used?

Do you really think abstracted shapes are new to man?

What kinds of shapes do you like best?

Do you know WHY you like those shapes?

What are ways you might produce nonobjective shapes?

Would the choice of your shape influence your choice of a format?

WHY?

KEYWORD to remember: SHAPE (an image)—

GEOMETRIC SHAPE
NATURAL SHAPE
ABSTRACT SHAPE
NONOBJECTIVE SHAPE

◆ What Can You Do with Shapes?

You can make them . . .

CUT
TORN
BIG
LITTLE
LONG
SHORT
FAT AND THIN
TOUCH OTHER SHAPES
ALMOST TOUCH
OVERLAP . . . and take them out of the space

and bring them back in to make them . . .

SHARE AN EDGE WITH ANOTHER SHAPE
. . . OR . . .
SHARE AN EDGE WITH THE SPACE
DARK OR LIGHT
RIGID
RELAXED
OPPOSE ONE ANOTHER
PROGRESS ACROSS THE SPACE
ANYTHING YOU WANT . . . as long as they
WORK for you!

◆ Can You Identify . . .?

Look at the following abstract figures. Which one do
you think was earliest? Which was the most recent? Is
the abstract figure new? Can you match the figures
with the dates?

A—2500–2000 B.C. F—Unknown
B—1949 G—680 B.C.
C—Unknown H—1907
D—25,000–20,000 B.C. I—2700–2600 B.C.
E—1900s

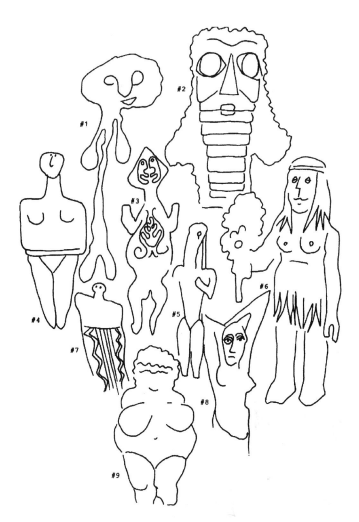

(Answers below)
Author/Author's Disclaimer: These line drawings that
represent historical art works are for educational
purposes only and are not to be considered as "copies"
of original art.

Answers

1—B 1949 "La Desesperanto" (Joan Miró)
2—I 2700–2600 B.C. Head of God Abu Tell Asmer
3—F ? Papuan Spirit Figure
4—A 2500–2000 B.C. Cycladic Idol
5—G 680 B.C. Mantiklos "Apollo"
6—E 1900s Folk Art—Michigan
7—C ? Native American (Barrier Canyon, Utah)
8—H 1907 "Les Demoiselles d'Avignon" (Picasso)
9—D 25,000–20,000 B.C. Venus of Willendorf

5◆10

A game

◆ Review

shape ◆ An image in space.

natural shape ◆ Shapes found in nature; sometimes called organic.

abstract shape ◆ A recognizable image that has been distorted or simplified.

geometric shape ◆ Usually man-made shapes that are precise, exact: triangles, squares, circles, rectangles, and the like.

nonobjective shape ◆ A shape often made accidentally or invented from another source. There is no recognizable object involved.

positive shape ◆ A shape or line placed in a negative or empty space.

negative shape ◆ The implied shape produced after two or more positive shapes are placed in a negative (empty) space.

6
Value

◆ What Is Value?

Value is the range of possible lightness or darkness that can be achieved with the particular **medium** you are employing in your design. It is a surface quality of a shape or line, such as a black line or a black shape. The range is usually thought of as the extremes from black to white and the grays in between. This means that the range available to print a photograph may reach only 18 or 19 values, or possibilities, whereas with mixing pigments for a painting, or inks for printing, it may reach a considerably higher range.

When we draw with a black pencil, we usually add what is generally called "shading," or medium to dark strokes, to give us the required darks and lights that we see. Just as a camera using black and white film, we are making a "value" interpretation of our colored world.

Most students have problems with values, especially in drawing. The reason for this is the relativity of values and the difficulty of learning to see the subtleties of values. Just about every design book has a value chart—and so do we. We explain that the values are relative. But what does "relative" mean?

◆ A Matter of Relativity

Relative means "in comparison to." Next to one of you, I may look short. Next to someone else I may appear tall.

Let's look at the VALUE CHART. When the strip that is medium gray is on the darkest value, the gray looks light, but not as light as white. On the lightest value, it looks quite dark. The gray strip hasn't changed, only its position *compared to other values*. Sometimes when we are drawing, there is no real black. A mid-value or even a medium-dark value may be the darkest, and all other values must relate to this as being the darkest. Once we have trained our eye to these subtle differences, or compared one dark to another, our drawings and

6◆1

This value scale has been rendered in pencil. It indicates the values that can be achieved with this medium. The gray strip to the left shows relative contrast. *Source: S. Brainard.*

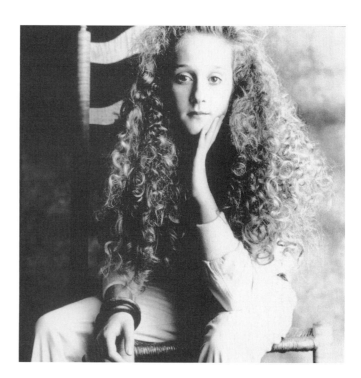

6◆2

TEEN GIRL SITTING ON A CHAIR. People are in living color. In a black and white photo, you can see the many values from the darkest dark to the lighest light.

Photographer: Camille Tokerud. Source: Photo Researchers, Inc.

other design works improve. We need to be aware of value **contrasts** and how to use them. White and black alone give you the extreme "highest contrast." Several values added from each direction create what is called a "medium contrast" while values close to one another give us a "low contrast"—or not much contrast. They may all be used and may play an essential role in our design, for they accentuate differences and, through contrasts, make our design more arresting to the viewer.

The most common use of values is to achieve the effect of volume, or the visual effect of the third dimension: that of depth and weight on a two-dimensional surface. Values are important in the creation of a three-dimensional effect, because without "shading" to round out our shapes, they would appear flat. But often we use flat shapes and *want* them to be flat. We would still use contrast in the "push-and-pull" of one value against another to distinguish one shape from another. When we are using gradual value changes to create this three-dimensional effect, it is crucial not to jump quickly from one value to another. This use of

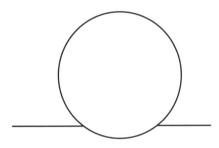

6•3

A circle with no values or "shading" looks flat, having no volume or depth.

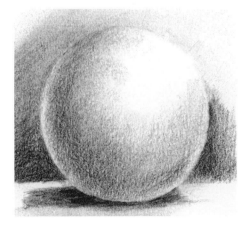

6•4

The same circle with added values makes the round shape appear as a sphere.

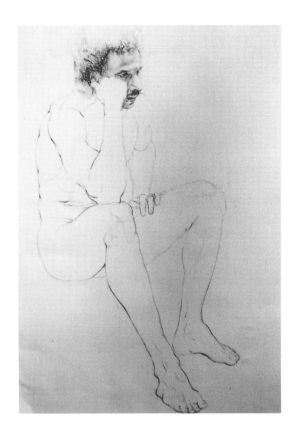

6•5

Kalon Baughan, MALE FIGURE. 1987. Drawing. Graphite on paper. 18″ × 24″. Adding values gives the head a three-dimensional effect. *Courtesy: Kalon Baughan.*

values is more prevalent in the fine art field of design than in the field of functional design.

The portrayal of values plays an important role in evoking certain responses from the viewer. We may want the viewer to perceive a special effect, like an emotional response, by the use of somber, darker values for the shadowy sides of life; or light values for the upbeat parts of our lives. Sometimes we may contrast these values to create emphasis, or to feature something else in the design that needs the attention.

What often seems like a contradiction in the portrayal of representational still lifes or landscape drawing and painting is the special effect of depth or distance. We use darker values to create *depth* but lighter values to create *distance*. Is there a difference? Depending on the subject matter involved, and recognizing particular shapes in the foreground, a dark value can create the perception of depth, or a "measurable distance down or into" a space. In other words, we can make a shape on a surface look as though it goes *into* and *beyond* that surface—or into a "hole"! Conversely, lighter values used in the background of a landscape gives the viewer the sense of

Dark values can indicate depth. *S. Brainard, Photo.*

Light values can achieve the visual effect of distance. *S. Brainard, Photo.*

greater space in terms of mileage. Darker values are usually used in the foreground to sharpen the details of the foreground.

The use of values is often misunderstood by the novice student. Values are the most intimidating of the elements. In beginning drawing, the student tends to make drawings too light, while the beginning painter usually uses colors that are too dark!

◆ Let's Think About Values . . .

Do values add interest?

Do value contrasts apply only to representational work?

Do you know how to evaluate one value against another?

Can you evaluate value differences?

What would happen if very close values were used in one design?

KEYWORD to remember: VALUE

◆ What Can You Do with Values?

Values Can Be Used:

TO CREATE A CONTRAST
TO ADD INTEREST
TO CREATE A VISUAL FEELING OF VOLUME, OR A THREE-DIMENSIONAL EFFECT
TO CREATE VISUAL DEPTH
TO CREATE VISUAL DISTANCE
TO CREATE EMPHASIS
TO CREATE A MOOD

◆ Can You Identify . . .?

The differences in value between the two photos of bulbs in figures 6–8 and 6–9?

Why does the difference in value make a difference in the way you see the photos? What would you do to correct either one?

6•8 and 6•9

BULBS. *S. Brainard, Photos.*

◆ Review

value ◆ The range of possible lightness or darkness within a given medium.

Medium ◆ The kind of material(s) one is working with, such as pigments, film, fabric, pencil, steel, and the like. (plural: media)

Relativity ◆ The degree of comparison of one thing to another. How does *a* compare to *b*; then what is the comparison of *a* to *c*?

Contrast ◆ The result of comparing one thing to another and seeing the difference.

7

Texture

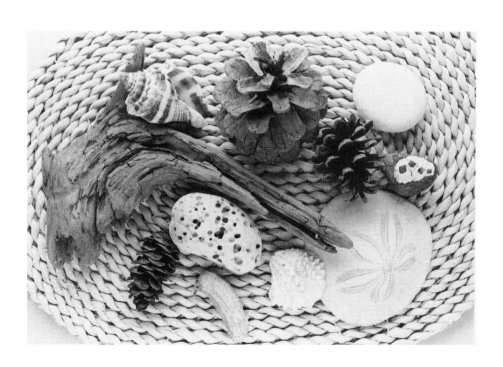

Figure 7•1

An example of thick paint on a painting. Called "impasto," it is real texture. *Source: S. Brainard.*

◆ What Is Texture?

Texture is the easiest element to describe because it is a visual surface quality. We are familiar with real texture, or a TACTILE surface, meaning "that which can be felt." The element TEXTURE on a two-dimensional surface is usually a **simulated** tactile surface, mentally interpreted as tactile. However, many designs have a real surface texture, which may have been created by the medium or technique used, such as "impasto" painting (using paint thickly, perhaps laid on with a palette knife); or a "collage" (a construction of various materials glued on a two-dimensional surface). Both are examples of work having real texture. Our definition of TEXTURE is "having a simulated or real tactile surface."

Look back at figure 4–12. Can you feel the coat of the animal?

◆ Rough or Smooth?

Texture is often thought of as something that is rough only, or has a structural feeling. But a smooth surface is also a texture.

Think of all the rough surfaces you can feel. Think of the smooth ones you can feel. What kind of textural sensations do you have when you eat? What can you think of as rough-against-smooth textural contrast?

Textures can be created in many ways, the most common ways are by using contrasting lines or values, directional lines, shapes placed close together, or rubbings from actual textural surfaces.

Figure 7•2

Detail of a collage showing fibers and miscellaneous real textures. *Pat Berret, Photography.*

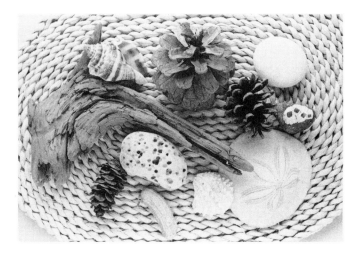

Figure 7•3

Nature creates many variations in texture. *Pat Berret, Photography.*

Figure 7◆4

Artist unknown. Embroidered linen cloth. The embroidery stitches create a raised surface that contrasts with the weave of the linen cloth. *Collection of the author.*

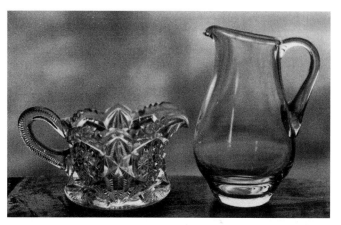

Figure 7◆6

Two pitchers—both glass—show contrasting surface textures *S. Brainard, Photo.*

Figure 7◆5

S. Brainard, THE GIFT. Pencil drawing (detail). Simulated texture based on the embroidered cloth. *Source: S. Brainard.*

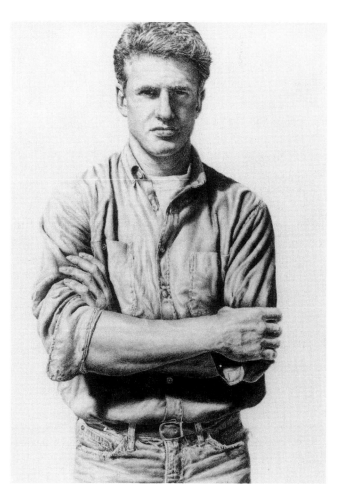

Figure 7◆7

Kalon Baughan, SELF PORTRAIT. Drawing. Graphite on paper. Note texture of hair, skin, muscles, and worn jeans. *Source: S. Brainard.*

◆ Can You Identify . . .?

By its visual quality, can you identify what each of these ten common textures represent?

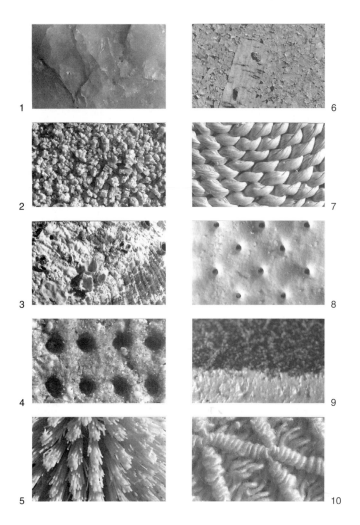

Figure 7•8

Textures. *S. Brainard, Photo.*

◆ Let's Think About Texture . . .

What are some TEXTURES you like?

ICE CREAM	LEATHER
SATIN	CHOCOLATE CAKE
CORDUROY	A NEW CAR
BRICK	FUR (THIS COULD BE YOUR PET FRIEND!)
RAW LIVER	YOUR HAIR
YARN	SOMEONE ELSE'S HAIR
POLYESTER	CUT GLASS
PLASTIC	WOOD
PLANTS	A PINE CONE

KEYWORD to remember: TACTILE—either simulated or real.

◆ What Can You Do with These Textures?

Can you depict them visually?

Can you produce any of these simulated textures by using *real* textures, perhaps by doing something like rubbings?

Can you do rubbings and have others identify the source?

◆ Review

texture ◆ The quality of being tactile, or being able to *feel* a rough or smooth-type surface.

simulated texture ◆ The real quality of a tactile surface being copied or imitated.

8
Color

◆ What Is Color?

Color is EVASIVE—
CONTRADICTORY
BEAUTIFUL
SENSUOUS
RELATIVE
DECEPTIVE
CONTRARY
LOVELY
FUN
LIVELY
MYSTERIOUS
AND . . .
PULCHRITUDINOUS!*

*The ultimate in beauty.

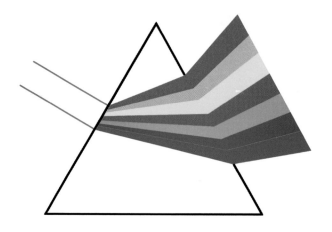

8◆1

A visual spectrum created by white light which has been broken (or refracted) by entering a prism. *(Plate 4.6 Design by Philip Rawson, p. 114.)*

Whole books have been written about color: What it is; what it isn't; comparative analyses; what colors look good with what other colors or color harmonies; how colors affect us mentally, emotionally, and even physically. Color has been used to soothe us, excite us, and label us. The *use* of so many colors is mind-boggling. But we must remember, when speaking of the basic rudiments of design, that *color is another element!* It must be considered as one with the other elements and used as the other elements are used.

Many academic design courses are separated into two areas: DESIGN Theory and COLOR Theory. In this book, we will keep color in perspective, and consider it as only WHAT is necessary in the practice of design.

COLOR IS NICE, BUT, AS FROSTING ISN'T NECESSARY TO A CAKE, COLOR ISN'T NECESSARY TO A DESIGN.

Most of us had a color wheel in our first-grade room in elementary school. This was probably our introduction to color, and we were told that yellow, red, and blue combined to make all the other colors.

Then, later in science class we were told that light made color, and we were shown pictures of sunlight going through a little triangle called a prism, resulting in a rainbow.

I don't know about you, but I was confused!

I thought a lot about theories . . . like, "If a tree fell in the woods would there be a sound?"—OR—"If the light goes out is there still color?"

We now know a lot more about color than we used to know, thanks to the sciences. We know that the physical and natural worlds work hand-in-hand so that we humans can experience the marvel of color.

Let's look again at that prism. This color mixture is the product of light. As the light—light that is produced by the sun—passes through the prisms of nature, as beams of light passing through drops of moisture and dust particles, they are broken up or "diffracted" into different wave lengths, or graduated bands of color. This is called a spectrum or, when viewed in its entirety reflected in the sky, a rainbow.

This mixture of color is called an ADDITIVE mixture.

The science of physics explains an **additive color mixture** as the addition of one light color vibration to another; the more color that is added, the more light you have.

In the 1660s, Sir Isaac Newton (of "apple dropper" and law of gravity fame) experimented with glass prisms, allowing light to pass through them and split up into a range of colors, therefore documenting the physical phenomenon of light. Today, many of us hang tiny glass prisms in our windows, producing little spectrums that dance and play on our walls on a sunny day.

Nature also produces *pigments,* substances that impart color to objects or materials. Every living thing has an *internal* pigmentation. There is "chlorophyll" in green plant life, "carotene" in carrots, "anthocyanine," which produces our red leaves in the fall, and "melanin" in humans, which determines our skin color.

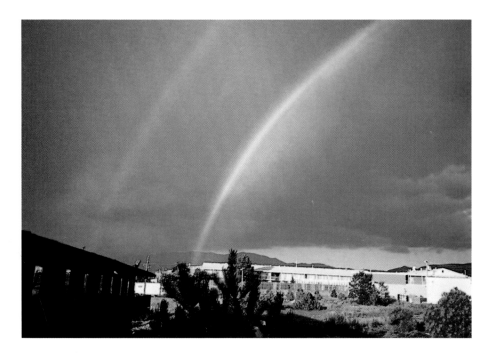

8•2

MOTEL 6-POT-O-GOLD. A double rainbow displays nature's spectrum—twice!
S. Brainard, Photo.

8•3

A glass prism hung in a window gives us "rainbows" on our walls. *S. Brainard, Photo.*

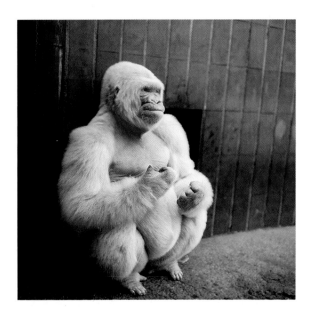

8•4

Albino Gorilla/Barcelona Zoo, Barcelona, Spain. A lack of pigmentation. *SuperStock, Inc.*

These are only a few examples. Sometimes nature goofs with the percentage of pigmentation assigned, and a mutation occurs. Then an animal or person may lack a degree of color and be very light or even white. This is called an *albinism*, or the state of being an albino.

Humans make another pigmentation, a coloration put on the *surface* of things. This is an *external* pigment.

External pigments are usually derived from natural sources, but they can be artificially produced in laboratories. Paints, chalks, lipstick, crayons, and eye shadow are a few of our external pigments. This color mixing process is the result of one color's exerting its force on another color. The essence of each original color is cancelled or *subtracted*, and something different from the two originals is produced. This production of pigments or color mixture is called a **subtractive** mixture.

Let's look at how the two worlds work together.

For example, sunlight goes through atmospheric prisms, splits up into spectrum rays, and then hits an object that is green because of its biological make up, like a tree, which contains chlorophyll. Each object reflects its own color and absorbs all others from the light it is reflecting. The *green* of the tree's chlorophyll is reflected back to us and is what we see.

The easiest way to explain this is that color is the reflection of light from a pigmented surface, which, through the eyes, is transmitted to the brain. Color is a sensory, not physical, experience. It cannot be touched or felt, except psychologically. This is why we respond to color in various ways.

NOW—*what happens* if there is a barn that a human has built and painted red next to the green tree—and a yellow flower—and . . .?

The world is filled with hundreds—THOU-SANDS—of colors, and we see them all at once. HOW? Through another wonder of nature—OUR EYES!

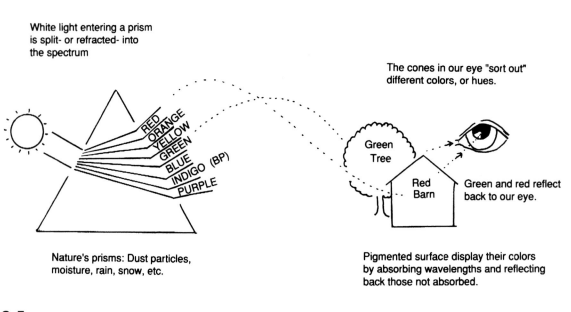

White light entering a prism is split- or refracted- into the spectrum

RED
ORANGE
YELLOW
GREEN
BLUE
INDIGO (BP)
PURPLE

Nature's prisms: Dust particles, moisture, rain, snow, etc.

The cones in our eye "sort out" different colors, or hues.

Green Tree

Red Barn

Green and red reflect back to our eye.

Pigmented surface display their colors by absorbing wavelengths and reflecting back those not absorbed.

8•5

Diagram: How we see color.

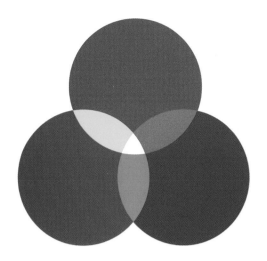

8·6

Example of *additive* color mixing. *(Plate 4.8 Design by Philip Rawson, p. 114.)*

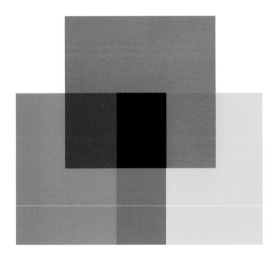

8·7

Example of *subtractive* color mixing. *(Plate 4.9 Design by Philip Rawson, p. 114.)*

Our eyes have about 6.5 million cones that take in and sort out various color sensations and send color "messages" to the brain. We have approximately 100 million additional rods that take in and sort out darks and lights. Both are photoreceptors that help make up the retina of the eye. This "sorting-out" process is unbelievable—but true. Our cones sort out the green tree, the red barn, the yellow flower, and the pink flamingo! The rods tell us whether the green is dark green or light green, the flamingo pink or red.

It will be easier to remember color production if we remember these two color mixtures. When electricity is used to produce light, in graphic computers, color televisions, and theatrical lights, all the color is produced by the additive method. Surface coloration, which is manufactured using natural or artificial pigments, uses color produced by the subtractive method.

ADDITIVE = LIGHT MIXTURE
SUBTRACTIVE = PIGMENT MIXTURE</DIS>

◆ Color Wheels

Newton, busy man that he was, also arranged the spectrum band into a circle to study the colors. Many color wheels have been developed since Newton's. A **color wheel** is no more than a visual method of charting colors for reference. Most are based on the use of the **primary** or first colors found in the color mixes. Research done in color laboratories has succeeded in recreating light mixtures, isolating pigment components, and experimenting to find the primary and **secondary** (second) colors for each color mix.

A PRIMARY COLOR CANNOT BE PRODUCED BY MIXING TWO OTHER COLORS, BUT, THEORETICALLY, PRIMARY COLORS CAN PRODUCE THE OTHER COLORS.

In the light mixture, it was found that red, green, and blue were the primaries; with yellow, cyan (a greenish-blue), and magenta (purplish-pink) as the secondaries.

In the pigment mixture, yellow, blue, and red are the primary colors, while green, purple, and orange are the secondary colors.

A SECONDARY COLOR RESULTS FROM MIXING TWO PRIMARY COLORS.

The subtractive color wheel, defined by Herbert Ives (after Newton's), is the one we knew in grade school. Because it is familiar and easy to use, we will use this wheel for reference in the rest of this chapter on color. All the other information or theory regarding color pertains to all color mixtures.

The combinations of the primary and secondary colors are the **tertiary** (third) colors you see on the color wheel.

So let's look at our color wheel. The primaries are yellow, blue, and red; the secondaries are green, purple, and orange; while the tertiaries—sometimes called "intermediates"—are yellow-green, blue-green, blue-purple, red-purple, red-orange, and yellow-orange. Notice the primary color is named first in these hyphenated tertiary color names.

IMPORTANT TO REMEMBER: *Color wheels are only reference charts.* We now know how color is

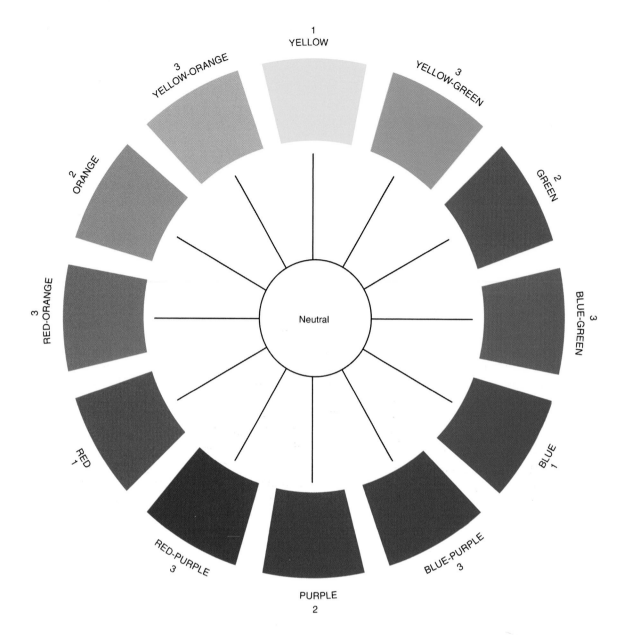

8·8

Example of one color wheel. *Courtesy Shirl Brainard.*

produced, how we see it, ways to chart it, and the basic colors.

The colors on the color wheel are *technically* called **hues.** COLORS are usually made from changes to these basic hues OR from the actual pigmented source. But we do not call these charts "hue charts"! (It is not uncommon to use the two words synonymously.)

◆ Color Identity

How do we identify all the colors we see?

There are three major properties to each color:

HUE

VALUE

INTENSITY

Let's try and define each.

HUE. Hue is the pure state of a color. A pure hue means the hue has not been changed or altered from its original state; it is virginal.

The easiest way to remember hue is that it is a family with a family name. All the names given a hue such as blue, like "Periwinkle," "Navy," "Cornflower," "Royal," "Indigo," or "Blueberry," tend to describe

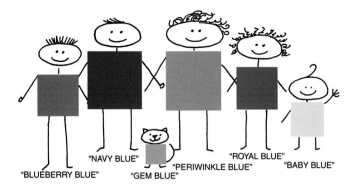

8•9

The blue (hue) family.

"NAVY BLUE"
"BLUEBERRY BLUE"
"GEM BLUE"
"PERIWINKLE BLUE"
"ROYAL BLUE"
"BABY BLUE"

something in our experience that we are familiar with and that we can identify with. They bring to mind an object which has a color that is close to the named color. Each color has many variations. Hue is the same as a family name like "Smith." How do you distinguish one Smith from another? *By first names.* John Smith and Marsha Smith are not unlike Navy blue and Baby blue. Names of colors tend to be fads, usually because of retail businesses, and a color may be one name one year and another name ten years later.

However, the names given to colors help us to mentally describe and identify the colors. Can't you mentally tell the difference between "Raspberry red," "Cherry red," and "Burgundy"? So we will learn to identify colors in a more academic way, using the three parts of a color's identity. To simplify, we will say that the colors on the color wheel represent families—twelve families that we will get to know.

VALUE. Value is the range of darkness or lightness of a color. Value scale relates to color the same as it does to the white-to-black values that we studied earlier. A high value of a color is one closer to white, while a low value is closer to black. Value has to do with HOW MUCH LIGHT—or quantity of light—we see on a color. If our green tree and red barn are observed at dusk when there isn't much light available, they may appear dark green and dark red.

When mixing pigments, *to change the value of a color* we add black to make it darker, white to make it lighter. If it is a darker color, we call it a **shade;** if it is lighter, we call it a **tint.**

We can now have dark hues, medium-dark hues, medium hues, medium-light hues, or light hues. We would say "a high value blue" for light blue hue.

INTENSITY. Intensity is the brightness or dullness of a color. This brightness or dullness has to do with the *kind* of light—or *quality* of light—a color receives. On a bright, sunny day, colors will appear brighter than on a dull, dismal day. Our green tree and red barn at dusk would look dark and *dull* if it were a rainy evening. But

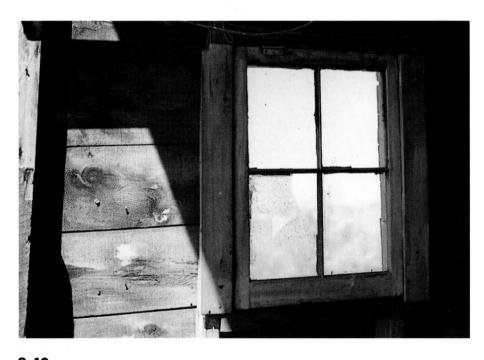

8•10

An example of dark and light *values* on colors. *S. Brainard, Photo.*

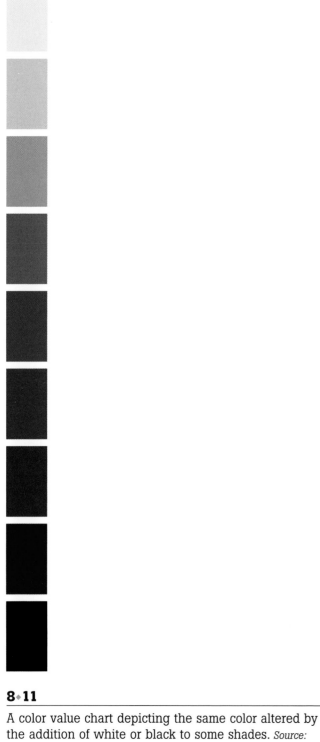

8·11

A color value chart depicting the same color altered by the addition of white or black to some shades. *Source: S. Brainard.*

just because a color is dark DOES NOT MEAN IT IS DULL, nor is a light color always bright.

A *hue in its pure state is at its brightest.* The colors on the color charts are pure hues. A color cannot be made brighter than its pure state. It can be changed to darker, lighter, or duller.

When a color is at its brightest, it is called HIGH **intensity.** When it is dull or grayish, it has a LOW INTENSITY.

The degree of color purity can be decreased in pigments in three ways. One is by dilution, such as when using watercolor. As more water is added to the pigment, the solution weakens and the color becomes less intense. This is like adding a lot of water to a cup of coffee to make two cups of coffee: The intensity of the color of the coffee, as well as the flavor, has been reduced.

The second way the purity of a color can be decreased in pigments is to add gray, a combination of black and white. If you add a *light* valued gray, the result will be a light, dull color.

The third way to decrease color purity is by adding the color's complement. What is a complement? Let's look at the color wheel again.

The color directly opposite any selected color on the wheel is called its **complement.** This is important information to remember, as complements will be referred to many times in the study of color.

If we choose blue as our color, the color opposite is orange. Orange is the complement of blue. So adding a touch of orange to our blue will LOWER THE INTENSITY of the blue, making it duller. It may also make it a tad lighter! DO YOU KNOW WHY? Look at the *value* of blue. It is darker than orange. The orange being lighter in value will bring up the value of the blue. WE ARE SPEAKING OF COLORS IN THEIR PURE STATE—PLAIN OLD BLUE AND PLAIN OLD ORANGE.

Sometimes colors are dark . . . and bright!

Sometimes colors are light and dull!

Sometimes colors are medium and medium!

Let's refer to our color wheel again. I recommend that we use the color wheel with the yellow at the top and purple at the bottom. In this way, we have a reference not only to the hues, or families of color, and their relative purity—and in this pure state they are all equally bright—but also to their relative values. The yellow at the top is, in its pure state, the lightest hue, with yellow-orange and yellow-green (on either side) a bit darker than the yellow, until as we go down the wheel laterally we come to purple, which is the darkest hue.

Do you remember seeing a gray circle in the middle of that grade school color wheel? That gray represented **neutral,** or what you get when you mix complements together. The thing is, you *never* get gray, you get a "grayed" or dull color—a **tone.**

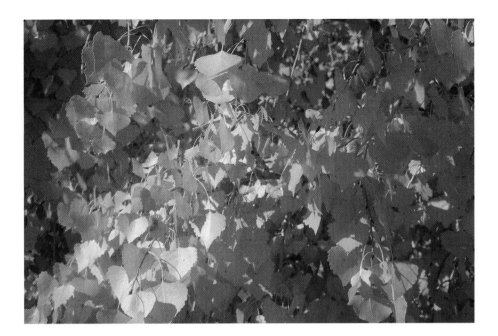

8◆12

This photo of cottonwood leaves shows a range of *tones* or a scale of bright to dullness of the leaves' colors. At the lowest range, the color becomes a neutral (a brownish color) and is also darker in value. *S. Brainard, photo.*

8◆13

Grant Wood (American 1892–1942), NEAR SUNDOWN. 1933. Oil on canvas. 38 × 66 cm. High-value, low-intensity colors are depicted in this painting. *Spencer Museum of Art, University of Kansas: Gift of Mr. George Cukor. Source: VAGA. © Estate of Grant Wood/Licensed by VAGA, New York, NY.*

What does neutral usually mean? That it isn't this way or that, it's in the middle! This is what a neutral is in colors also. When we use our complement to lower the intensity of a color to the point that neither color is evident, but the mixture is something in between, it is neutral. Our blue, for instance, with enough orange added, wouldn't be blue, but it wouldn't be orange either. It would be neutral.

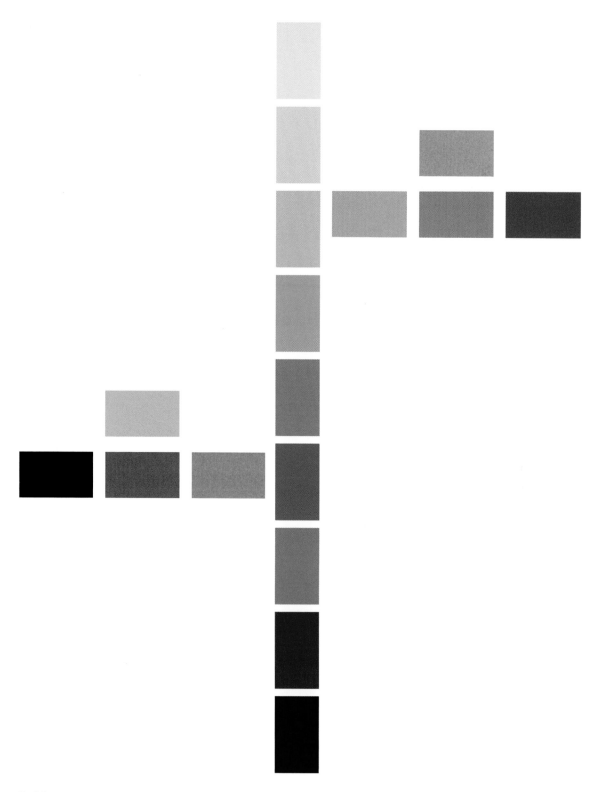

8·14

A color intensity chart showing how the same hue can be altered to make *tones* by the addition of grays or by the addition of the hue's complement. *Source: S. Brainard.*

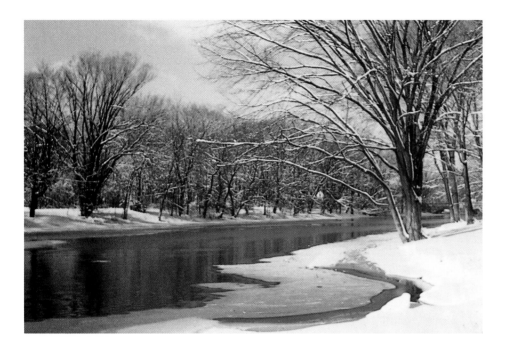

8•15

WINTER. This winter scene makes us feel cool perhaps because of our experience with winter and the colors associated with coolness. *S. Brainard, Photo.*

Many colors we know are colors made from neutralizing colors. "Brown" is the lowered intensity of orange, while "khaki" is the lowered intensity of green. Our tans, beiges, taupes, and so on are all neutrals. (These colors may also come from natural pigments.) A technical explanation of gray is that it is produced by mixing a black and white pigment. Gray is achromatic, or without color.

Let's remember: *Intensity is the brightness or dullness* of a COLOR. If the INTENSITY has been modified, it is a *tone*. If it has been changed to the point of no recognition (by its complement), it has become a *neutral*.

There are many colors of one hue. For instance, there may be ten natural sources for a blue pigment. We can add them all into our original family. Then we can change all those blues by value and intensity, and we begin to see how many colors are possible within one family. Then we can mix some of the blues together and get still different blues, and then we can change the value and intensity of those blues . . . WOW!

COLOR TEMPERATURE. I am of the opinion that there is a fourth important identification that should be learned, and this fourth identity is **color temperature.**

When we speak of a color being WARM or COOL, we're not referring to an actual physical quality of the

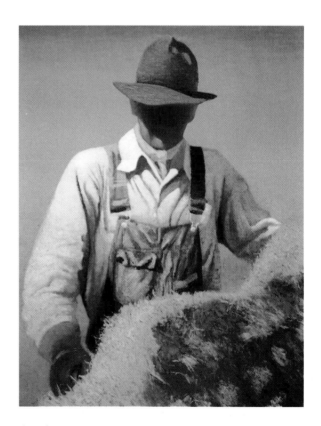

8•16

Gary Ernest Smith, MAN WITH STRAW BALE. Oil on canvas, 48″ × 36″. What kind of temperate feeling do you experience looking at these colors? *Courtesy: Overland Gallery of Fine Art, Scottsdale, AZ.*

color but an emotional or aesthetic quality. However, when we *experience* actual heat or cold, the colors we associate with either can help us. HOT or WARM reminds us of fire, or sun—red, yellow, orange—but also the bright blue of a very hot flame. These colors are usually *bright,* with perhaps a medium or even dark value. On the other hand, COLD reminds us of ice, snow, or gloomy days that make us feel cold. These colors of association are usually light, maybe white, and, *perhaps,* dull.

We have been taught that the colors on the color wheel—red-purple through the reds, oranges, and yellows to yellow-green—are considered "warm"; while green through purple are the "cool" colors. Each color, however, has its own degree of warmth or coldness as a *pigment.* Remember those ten blues a few paragraphs back? Blue is supposed to look cool. Why, then, does one look warm? The degree of apparent "visual" warmth or coolness depends not only on the individual pigment but also on WHAT OTHER COLOR IS PLACED ALONGSIDE IT. Our blues will all look cooler next to yellows—right? WRONG! If a blue's value is darker and its intensity very bright, and if the yellow's value has become almost white, the yellow will appear cooler!

It takes close observation over time to see these variances. For safety's sake, let's remember the following usual temperate appearances:

WARM—HOT = Bright (high intensity) Medium to dark value

COLD—COOL = Medium (low intensity) High value

◆ Color Perception

This is a good time to discuss **perception,** which plays a HUGE part in color. The viewer's—as well as the designer's—perception of a given color may vary a little, or a lot.

Perception has to do with stimuli to our senses. It also has to do with what we were exposed to as we grew up.

Let's think about our chocolate cake again. In our Western world, and especially in the United States, chocolate cake is very common! In some countries, however, people may be well acquainted with chocolate but *not* with "cake." If I hear "chocolate cake" or see a picture of a chocolate cake, it evokes a taste and smell sensation—and I want some! However, if we have never had a piece of chocolate cake, then this doesn't work. But it doesn't mean that we

can't acquire a taste for it—we can . . . and probably will.

If we have never been exposed to a wide variety of experiences, we have a limited number of comparisons. If we've been taught one thing and lived with that information for many years, it is sometimes difficult to quickly adapt to new ideas. This often happens with color. If we haven't developed an awareness of many color variations (and we do take colors for granted), it can be very hard to "see" the differences in 20 different blues.

This often occurs in the classroom as we try to identify colors by "hue, value, intensity, and temperature." Some of us will catch or perceive any slight nuance of modification, while others may be able to identify only one or two changes.

But color perception can be learned, so don't worry. Again, time and practice are the keys.

We could describe one blue from another in this way: "blue hue, medium value, high intensity, and warm," while its partner may be "blue hue, high value, medium-low intensity, and cool."

See how many colors of one hue you can identify in this way. In my classes, we have a BLUE-DAY or RED-DAY and we all wear the same hue. VERY INTERESTING!

◆ Color Interaction or "Those Lying Colors"

We have been thinking of comparisons. We NEVER see one color all by itself. There are always other colors around it, and so one color always relates to another.

Color is the most relative element. Its behavior will change with its environment!

This is very sneaky and deceptive!

You may see a color that looks bright blue and along comes another blue and the first looks like a dull . . . green? Or what about that red sweater you bought that you just *knew* would go with your red plaid skirt? That sweater now looks absolutely ORANGE! So, you'll wear the sweater with another plaid skirt that has blue-green, rust, and orange in it. Now the sweater looks RED! We spoke of similar comparisons when talking about color temperature, variations of colors, and the like. It happens all the time!

All of these comparisons have to do with the **interaction** between colors, and this is why color can be deceitful.

Think how you would feel if you owned a successful neighborhood meat market and had the same reli-

8•17

Example of blue pigments (all blue hue) in their pure state. Does one look warmer than others? If so, *why?*
Source: S. Brainard.

able customers for years. Your shop has been painted a sterile white all this time and is showing its wear, so you decide to do a little redecorating. Reading somewhere that yellow was a cheery color, you paint your interior a nice, bright yellow . . . and slowly, but surely, your loyal customers leave your store without buying, and many never return. WHY? It was found that the yellow walls made the meat look . . . PURPLE! A "color-fairy" comes along, whispers in your ear to paint the walls a nice "mint" green, and PRESTO! your business shoots upward again!

In human psychology or color consulting, this is a common story. The experience is called seeing an "after-image," and it happens after we have consciously, or unconsciously, stared at a color for a length of time—as we would be apt to do standing in line at a grocery counter. When we suddenly look elsewhere, we see the *complement* of the color we were looking at, often in small geometric shapes.

What is important to realize is that unusual things can and do happen with color, and we should plan for those unexpected events. As a painter myself, I often "mentally" paint while driving, before I physically pick up my brush. We all do masterpieces in our heads, but then it often doesn't come off! When faced with such a failed masterpiece, we have to analyze the basic design, the color. We have to see WHAT went wrong, and make corrections.

The control of color—and good color usage is control—comes not only from the choice of colors we use, but, as with the other elements, from HOW we use them. We have to be careful how our colors act and react together; we must plan their contrasts.

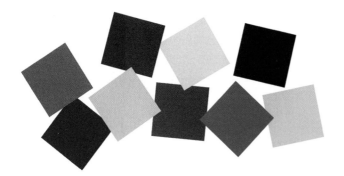 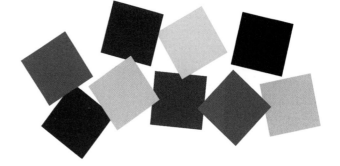

8•18 and 8•19

A color's behavior depends on the colors around it. *Source: S. Brainard.*

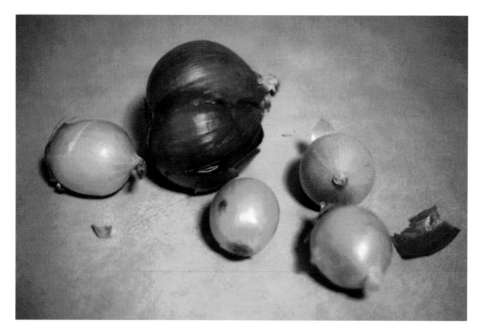

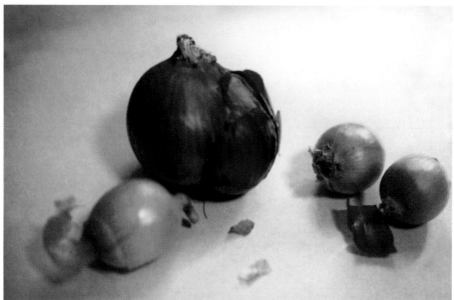

8•20 and 8•21

The same onions with different backgrounds. Which appears cooler? *Why?*

S. Brainard, photo.

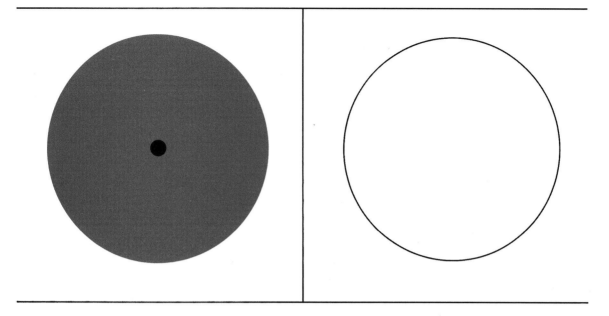

8·22

Stare at the black dot on the red circle for a full minute—then shift your eyes to the white circle. *What do you see?* Source: S. Brainard.

◆ Color Contrasts

We talked of contrasts in the chapter about value. Remember high contrasts and low contrasts? With color, there are four major **contrasts,** and the capable colorist will carefully consider color placement. Let's look at the contrasts:

DARK/LIGHT—BRIGHT/DULL—
WARM/COOL—LARGE/SMALL

1 ◆ Dark/light is the relative contrast between values of colors. This could be a dark red to a light yellow; a dark red to a light red (which could be pink); or a dark neutral to a light red.

2 ◆ Bright/dull is the relative contrast between intensities of colors. This could be a dull red to a bright red, or a dull red to a bright blue, or a dull neutral—(neutrals are already dull)—to a bright red.

3 ◆ Warm/cool is the relative contrast between temperatures of colors. This could be yellow to blue, or bright blue to pale, light yellow; bright red to pale, light blue, or hot pink to blue-green.

COULD ALL OF THESE CONTRASTS BE IN ONE COMBINATION? Can a dark, bright, warm, sensitive red find happiness with a light, dull, cool, sweet blue? Sure they can!

4 ◆ Large/small is the relative proportion of one color to another, with one color usually dominant. Sometimes one color will dominate other colors; we may remember a "red" painting and know that we observed other colors but not recall what they were. This is an example of contrast of quantity—how much "red"—(and these may be different reds)—compared to the amounts of blue, green, purple, or any other colors.

◆ More Color Contrasts

In the use of color, one solution for unifying color (see UNITY in the section on the PRINCIPLES) is the use of a "color system."

"All colors are the friends of their neighbors and the lovers of their opposites," wrote Marc Chagall. He was speaking of the use of color "systems" ("harmonies," "schemes") or "simultaneous contrasts," as their founder, Michel-Eugène Chevreul, called them.

In the early 1800s, paints were mixed by chemists. Michel-Eugène Chevreul (1786–1889) was one such chemist. He spent his life fascinated by pigments, their properties, and the interaction between the colors these pigments produced. In a scientific journal he gave a report on **"Simultaneous Colour Contrast,"** which evolved into his basic color harmonies, based on the

JAPANESE GARDENS. Dark/light contrast. *S. Brainard, Photo.*

8·24

LUNASCAPES, Watercolor by Pauline Eaton. Bright/dull contrast. *Courtesy: Pauline Eaton.*

8•25

Cindy Carnes, KOI. Pastel on sanded p. paper, 24″ × 30″. How many color contrasts do you see in this painting? *Courtesy: Cindy Carnes.*

traditional *pigment* color wheel. (The "light mixture" or "additive" mixture wheel differs from the pigment wheel.)

In 1920, Josef Itten taught these concepts at the Bauhaus (remember the Bauhaus?) and Josef Albers (1888–1976) was one of his students. Both went on to do scientific research about color, resulting in new applied studies about color. Here, we'll look at Chevreul's basic color harmonies, now called "systems" or "schemes."

8•26

Mark E. Mehaffey, VISUAL LAYERS, RED. Mixed water media. Red is the dominant color. *Source: Mark E. Mehaffey.*

8•27

Nature's complements, purple and yellow wildflowers blanket a field. *S. Brainard, Photo.*

8·28

Nurseries often use color contrasts with flower displays. *S. Brainard, Photo.*

We readily see these select contrasts in many design areas. Look for them in textile/fabric design (clothing, upholstery, bed linens, drapery, and table linens), home decorating (a speciality of interior Design), graphics, and photography (especially in high-end magazines that use free-lance photographers for advertisements).

It may have been in the observation of nature that Chevreul saw some of these color harmonics because the complements are familiar in nature settings, seen in the coloration of the flowers, and in nurseries, gardens, and floral designs everywhere.

The complements have also been used by painters (Cezanne loved them), and that one contrast is used by many painters today, whereas the other contrasts aren't as common. Intensities and values may be changed in any of these contrasts. Often in the use, a contrast will AUTOMATICALLY become a contrast of light and dark, or warm and cool. All of these contrasts make interesting learning exercises for the painter.

1 ◆ COMPLEMENTARY: These *two* hues we've been introduced to earlier. TWO hues that lie directly opposite one another on the traditional color wheel tend to intensify each other visually.

8·29

Nature uses complements with flowers, often seen in their stems and/or leaves. This daisylike flower is pale yellow-orange with blue–purple center. *S. Brainard, Photo.*

8·30

Complementary color chart using red-orange and blue-green. *Source: Shirl Brainard.*

8·31

Complementary color chart showing a hue and its complement with value changes. *Source: Shirl Brainard.*

8·33

Susan Weeks, UNIFOLIA. Uses complements red–purple and yellow–green. Source: Susan Weeks. *Courtesy of Susan Weeks.*

8·32

James McGulpin, YELLOW SPIDER CHRYSANTHEMUM, oil on canvas. *Source: James McGulpin.*

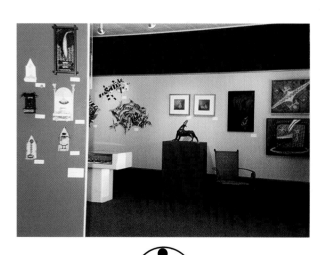

8·34

Interior of Corrales Bosque Gallery in New Mexico, with purples and yellows on its walls. Source: Corrales Bosque Gallery. *Courtesy of Corrales Bosque Gallery.*

2 ◆ SPLIT-COMPLEMENT: This is a combination of *three* hues, a chosen hue and the hues on *either* side of its complement. Such a combination produces a dramatic effect.

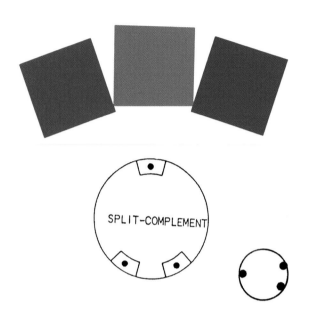

8◆37

African motif fabric using split-complements red, yellow-green, and blue-green. *Source: Shirl Brainard.*

8◆35

Split-complement chart using red-orange, blue, and green. *Source: Shirl Brainard.*

8◆38

Julie Hopkins, 5 PM. Oil. A split-complement combination of purple, yellow-orange, and yellow-green. *Source: Julie Hopkins. Courtesy of Julie Hopkins.*

3 ◆ MONOCHROMATIC: The use of *one* hue (using different pigments of the same hue), usually with value and intensity changes (see Figure 8–15). Many times a design may be perceived as monochromatic, but on closer scrutiny, other colors are seen. This then, is the *dominant contrast* we spoke of earlier. A truly monochromatic design creates a feeling of calmness or elegance (in an interior), but it can lead to boredom.

8◆36

Shirl Brainard, A MATTER OF OPINION. Paper collage/water media. Split-complements are red-orange, green, and blue. *Source: Shirl Brainard.*

8·39

Monochromatic chart showing *one* hue with value and intensity changes. *Source: Shirl Brainard.*

8·41

Two fabrics, both all blue. *Source: Shirl Brainard.*

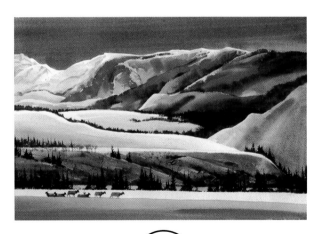

8·40

Susan Weeks, PEARS AS LANDSCAPE. Watercolor. A range of yellow-oranges makes this a monochromatic color system. *Source: Susan Weeks. Courtesy of Susan Weeks.*

8·42

Stephen Quiller, WINTER RHYTHM, TWILIGHT, SAN JUAN. Watercolor. 21″ × 29″. Various blues make this monochromatic color system. *Source: Stephen Quiller. Courtesy of Stephen Quiller.*

8·43

Susan Weeks, WINTER THAW. Watercolor. Often a work will *appear* as monochromatic. When looked at closely, however, other colors will be seen to have been used to enhance the *dominant* color. *Source: Susan Weeks. Courtesy of Susan Weeks.*

4 ◈ TRIAD: *Three* hues equal distance from one another on the color wheel. This combination can be energetic.

8·45

Aleta Pippin, IN BLOOM. Red, yellow, and blue make this triad color contrast. *Source: Aleta Pippin. Courtesy of Aleta Pippin.*

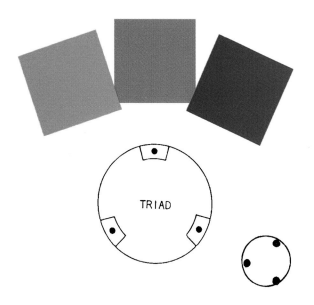

8·44

Triad chart using red–orange, blue–purple, and yellow–green. *Source: Shirl Brainard.*

8·46

Susan Weeks, BELLFLOWER. Watercolor. A triad combination of purple, green, and orange. *Source: Susan Weeks. Courtesy of Susan Weeks.*

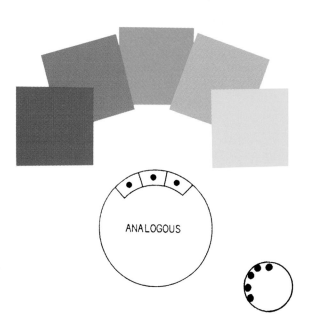

8·47

Analogous chart with yellow, yellow-orange, orange, red-orange, and red. Five neighbors on the color wheel.
Source: Shirl Brainard.

5 ◆ ANALOGOUS: Something similar is the meaning of this mixture. Made up of *three* to maybe *five* hues lying next to each other on the color wheel. When *three* to *four* are used, they share one hue in common; if *five* are used, another major hue is involved. This creates a dynamic effect.

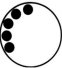

8·48

Nature produces analogous colors in the rose, such as in the "Joseph's Coat" rose, with pale yellow, yellow-orange, orange, red-orange, and red. *S. Brainard, Photo.*

8·49

Single "Joseph's Coat" rose. *S. Brainard, Photo.*

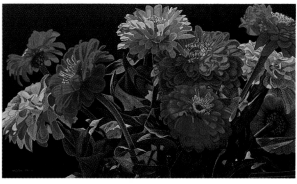

8•50

James McGulpin, ZINNIAS. Oil on canvas. Analogous combination of yellow-orange, orange, red-orange, red, and red-purple. *Source: James McGulpin.*

8•51

Shirl Brainard, SPIRIT OF THE SIPAPU. Acrylic. 18″ × 24″. This analogous painting uses the full side of the color wheel from yellow to purple. *Source: Shirl Brainard.*

These contrasts can be instrumental in creating a successful design.

We can't forget that color, like value or texture, is often on the surface of our shapes and lines and, being mutually supportive, they are *all* arranged to work together in a given space. Theoretically, a good design planned out in a black-and-white value range *should* work as well in a color range, but control is the winning factor in good color usage.

Color is a "part"—another ELEMENT. It can be used in our design like the other elements, and the principles will determine HOW effective that design is.

But—never, never turn your back on COLOR! Even Leonardo da Vinci noted, "Colors appear what they are not, according to the ground which surrounds them." And Josef Albers said, ". . . in order to use color effectively, it is necessary to recognize that color deceives continually."

When an artist has learned the use of color contrasts (as well as other color theories), it often appears to be second nature to a designer, but a thinking process is usually going on in the artist's mind. The painting *Gallo* (or "Rooster") by artist John Nieto (figure 8–52) is an example of this use of color contrasts that we have been talking about.

The rooster itself has very bright, warm colors. There is a light, bright yellow along the back of the bird, with pinky red-purples, reds, red-oranges, and oranges forming the main body. Let's look at this paint-

ing, color to color, as a journey through the SPACE that makes up this work. The yellow is lighter, but not brighter, than the red to red-purple next to it, used as background (or negative space). This red-purple is next to a band of blue-purple that runs across the top of the painting. This band is lighter over the bird's head than on the left side, and the right side is darker but still relatively bright. This band moves to the tail, which is blue-green, and changes to a lighter value, to almost white (lower left on tail) and lighter, but a tiny bit duller on the right. This, then, turns to a bright blue (repeated on the lower body of the bird), which meets with a dull, warm, medium-to-dark value yellow-green. This also changes values until it meets its complement (remember complement? Yellow-green and red-purple are complements!) of red-purple, which also runs in a band across the bird's feet. It changes to a very light value and bright pink; then to a red that repeats the red by the upper body background. This band, from right to left, is a dark, dull red (lower right), which is a mid-value, but changes to a lighter— but not light—value toward the left side.

There is a bright, mid-value streak of red-purple (perhaps we would call it fuschia?) on the left of the pink that connects with the foot. This brightness contrasts with duller, mid-value to the extreme dark value, almost black, above it. This very dark blue-purple varies in value, but not intensity, throughout this

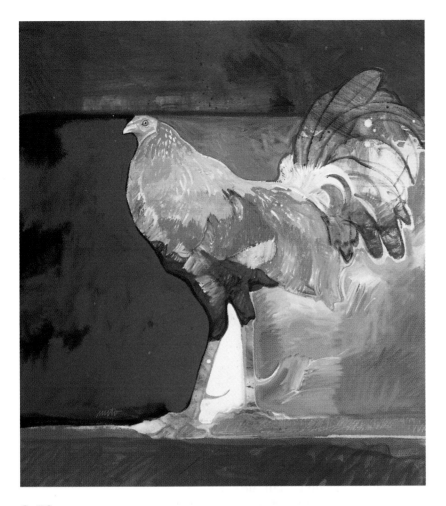

8·52

John Nieto. GALLO. Acrylic on canvas. 44″ × 40″. *Source: John Nieto.*

larger negative space, with a lighter blue-purple next to the breast and legs of the bird.

Did you think there would be so many dark-to-light, dull-to-bright, warm-to-cool contrasts in one work?

◆ Let's Think About This Painting . . .

Look at figure 8–52.

What is the darkest color?

What is the lightest?

What is the brightest?

What is the dullest?

Which color is the warmest?

Which color is the coolest?

Is there a neutral "color"?

Is it warm or cool?

Is a color repeated?

Is there a dominant color?

Is there another color next to its complement?

What would have happened if the white area between the legs (actually, a high-value blue) were not there?

Why do you think the legs are blue and not some other color?

◆ Let's Think About Color . . .

Do you have chromophobia?

Can you verbally describe the difference between:

lilac

purple

lavender

violet

orchid?

Why would you change the intensity of a color?

If you change the value, does the intensity change?

If you change the intensity, does the value change?

Can you describe "pink" by hue, value, and intensity?

Could "pink" have different intensities?

Why would a landscape painter want to know about warm or cool colors?

Why would an interior designer want to know about warm or cool colors?

Can you describe the clothes your colleagues are wearing by hue, value, and intensity? How about temperature?

If you mix two complements, what do you have?

What happens if you add white to the above resulting color?

If you use the two complements and the above result together in *one* project, what kind of color system do you have?

If you use red, yellow, and blue in *one* project, what kind of color system do you have?

If you use yellow-green as your chosen hue, what hues would you choose to make a "split complement"?

KEYWORD to remember: COLOR—*relativity; color is an element.*

◆ What Can You Do with Color?

Can color create a focal point? How?

Can color be used as emphasis?

Can color be used to manipulate a viewer's feelings?

Can we divide space with color?

Can color be a negative space?

Can color be a shape?

Can color be a line?

Can color have texture?

Can color have value?

Can we use color to create balance?

Can rhythm be created with color? HOW?

(Refer again to figure 8–52, *Gallo*.)

◆ Can You Identify . . .?

1. What kind of shapes are predominant?

2. Is line important?

3. Is there a value contrast?

4. Is there a visual textural area?

5. What color dominates?

6. What do you think the red color does?

7. Do you have any idea "what" balances "what"?

 The line?

 The shapes?

 The color?

8. Do you have any idea HOW the elements are held together or HOW "unity" is established?

9. What is the "focal point"?

10. Numbers 7, 8, and 9 were questions about HOW the elements are used, or composed, using the PRINCIPLES of design, which we'll study next.

8•53

John Shannon, A NINE'S PERSPECTIVE. Mixed media.
Source: John Shannon.

◆ A Preview of Things to Come

When we later discuss three-dimensional design, we will see that the element **color** is as important to that type of design as it is in two-dimensional design. Let's preview three illustrations that all depict three-dimensional design and look how color is used in each.

8·54

Rick Satava, ONE–OF–A–KIND GLASS JELLYFISH. 6″ × 24″. Colors abound in this glass piece. *Source: Rick Satava. Courtesy of Rick Satava.*

8◦55

Joy Franklin, SUN DANCE CEREMONY. Stained glass, found bone and feathers. 24″ × 24″ × 6″. Artificial or natural light shows the colors in this work. *Private collection. Source: Joy Franklin.*

8·56

Steve Kline, LETTERS FROM HOME. 18″ H × 10″ L × 6″ D. This fun sculpture of welded painted steel is full of color. *Courtesy: Steve Kline. S. Brainard, Photo.*

◆ Review

additive color mixture ◆ The result of diffracted light reflected to our eye from a surface; color produced by light.

subtractive color mixture ◆ The result of pigments mixed together and exerting their force upon one another.

color wheel ◆ A reference chart for colors.

primary colors ◆ Colors that cannot be produced by mixing other colors. Theoretically, all other colors can be produced from the primaries.

secondary colors ◆ Colors produced by mixing two primaries.

tertiary (intermediate) colors ◆ Colors produced by mixing a primary and a secondary color.

hue ◆ A "family" of color; the pure state of a color.

value ◆ The range of possible lightness or darkness within a given medium.

shade ◆ A dark value of a color.

tint ◆ A light value of a color.

intensity ◆ The relative purity of a color; brightness or dullness.

complement ◆ The color directly opposite a selected color on the color wheel.

tones ◆ Neutrals of colors; relative neutral scale.

neutral ◆ The color resulting after two complements have been mixed to the point where neither color is evident.

temperate colors ◆ The apparent psychological or emotional state of warmth or coolness of colors.

perception ◆ The individual response to the sensations of stimuli. Often cultural.

color interaction ◆ The relative differences between colors as they react to one another in different environs.

contrast ◆ The result of comparing one thing to another and seeing the difference.

Simultaneous color contrast ◆ A system of contrasting colors as defined by Michel-Eugène Chevreul using the traditional color wheel.

Color systems (schemes, harmonies) ◆ Synonymous with "Simultaneous color contrast"

Split-complement ◆ Three hues; one hue and the hues on *either* side of its complement.

Monochromatic ◆ One hue with value and/or intensity changes.

Triad ◆ Three hues at *equal* distance from one another on the color wheel.

Analogous ◆ "Alike" hues. Three to five (or more) hues lying next to one another on the color wheel.

9

Space Division & Balance

◆ Use of the Elements

We have now considered all of the design elements. It is as if we were looking at those ingredients for our cake: flour, sugar, butter, eggs, flavoring (chocolate preferred), and so on.

The cake ingredients, like our elements, are not exciting by themselves. They have to be put together and it is HOW they are put together that results in a "WOW" of gratification . . . or . . . an "OHhh . . ." of disappointment.

The *principles* are *how* the elements or components of a design are used or composed. They are considered guidelines only because all these elements can be combined in millions of ways and still be a good design. There is no right or wrong—only designs that work well and those that do not. If the design is successful, all the parts will work together as one total form and will attract and affect the viewer as the designer intended. If it is semisuccessful, the viewer may consider the design momentarily but not as the designer wished. And if it fails to attract the viewer at all, let alone hold the viewer's attention, it can be considered a failure.

As Edgar Whitney, artist, said, "Every time you make conscious choices in design, you sharpen your taste, and good taste is nothing more than information at work."

We will look at how we can manipulate our elements in our space, considering the following principles of design: space division and balance, unity, and emphasis.

◆ Dividing Space

We are now ready to examine how we can combine the parts to create the total effect we call a design.

First, we choose a space to use for our design. One of the first things we do automatically, without realizing what we are doing, is to divide or break up that space.

SPACE IS BROKEN BY NEGATIVE AND POSITIVE SHAPES

The *instant* we draw that horizon line in our pictorial space, we have divided our space into TWO areas. Or when we place one shape into a negative space, we have "broken" the emptiness of that space. Think of it in terms of something tangible, like putting one chair into an empty room. This placement immediately creates a charge of energy in the space. It breaks up the space and makes both the space and the shape more interesting.

As we place a *second* shape into our space, we break up the space even more, and we now have to start thinking about the *relationship* of our shapes to *one another*, the relationship of our shapes *to the space*, as well as to the *negative shapes* that may be formed in the process. The more shapes or lines (which are also

9◆1

TWO STONES. This placement of two stones is practicing the principles of design with only an aesthetic purpose in mind. "It is salutary that in a world rocked by greed, misunderstanding, and fear, with the imminence of collapse into unbelievable horrors, it is still possible and justifiable to find important the exact placement of two pebbles."—*Jim Ede. aesthete and collector.*
S. Brainard, Photo

9◆2

Diagram 1. A shape put into a space breaks up the space. This action energizes the space.

positives) that are added to our space, the more complicated this relationship becomes. It becomes a **complex** design, as opposed to a **simple** design, where only a few shapes or images are used.

◆ Balance

When we divide or break up our space, we commit a physical act. Think of it as something we actually DO in our space. We make it happen.

We, as humans, tend to see bilaterally—from side to side rather than up to down. In Western culture, we usually look at a two-dimensional space from left to right. If, then, we place something on the left with nothing on the right, we perceive an **implied axis,** or "a line that really isn't there," down the center of our space, dividing the space in half; we create a design that forces the viewer to make a *mental* division of the space. We are an orderly people and we want those two halves to balance or we feel uncomfortable with the design.

Often viewers don't know WHY they don't "like" a design; they just don't. It doesn't fit their need for harmony and balance even though they may not know it. So balance and **space division** affect one another.

Let's define **balance** as positive and negative spaces or shapes distributed in space by apparent VISUAL

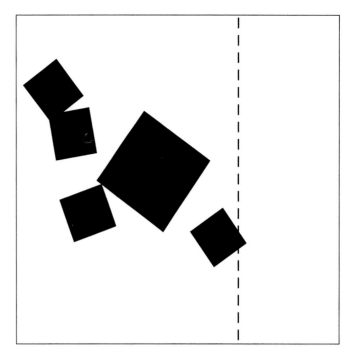

9◆4

Diagram 3.

weight. We can use any or all of our elements to create balance. We may balance a shape with lines, or lines with value, or many lines together to balance a color, and obviously with shapes to shapes, and the like.

◆ Kinds of Balance

There are known balance systems we can employ— ways to use our elements to achieve a balanced effect. I think it is important to be aware of several of the most frequently used balance systems and the differences among them.

1. SYMMETRICAL. When we divide our space with that "implied" vertical axis and divide our space equally into halves, the easiest and most common balance system to employ is **symmetrical** or **formal** balance. *Symmetrical balance has the exact identical weight on both sides of the implied axis.* A very technical definition of this balance system says that not only are both sides identical in weight but that they also share *identical imagery in reverse.* This is called "mirror image." Formal balance is instantly understood as it requires little of the viewer. It is exacting, noncasual, and quiet, but it can also be boring.

SYMMETRICAL balance is USUALLY (but not always) found in functional design, and it can be found in buildings, cars, clothing, furniture, and so on.

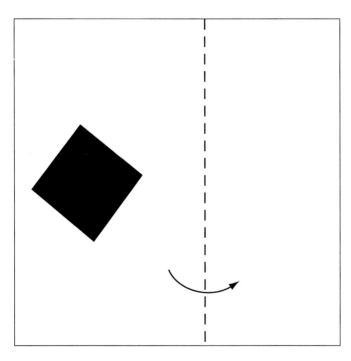

9◆3

Diagram 2.

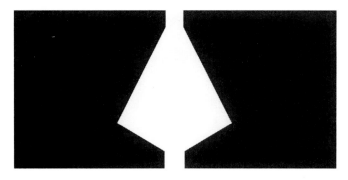

9•5

Diagram depicting two *identical* shapes in a mirror-image design creates an immediate *formal* balance.

9•6

Two exactly alike cups in opposite positions create symmetrical balance. *Source: Shirl Brainard.*

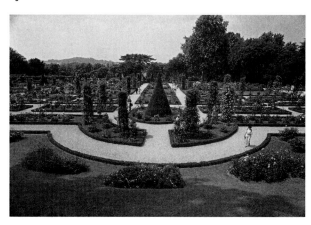

9•8

One of the formal gardens in the Bois de Boulogne, Paris. Max Alexander, Photo. *Source: Dorling Kindersley Media Library. Max Alexander © Dorling Kindersley.*

9•7

Eighteenth-century English mahogany high chest. Both sides of the chest are exactly the same but in reverse. An example of *formal balance. Courtesy: Baker Furniture, Grand Rapids.*

9•9

Frank Gehry, architect. CHIAT/DAY ADVERTISING AGENCY BUILDING (1991) in California. Combined with sculptor Claes Oldenburg. Neil Setchfield, *Photo. Source: Dorling Kindersley Media Library. Neil Setchfield © Dorling Kindersley.*

2. ASYMMETRICAL. The second most common type of balance system is **asymmetrical,** or **informal** balance. In this system, the space may be divided in unequal parts and, therefore, the elements must be placed with care to distribute the weight and create the needed balance. The *visual weight* is EQUAL but NOT IDENTICAL. This system is really used more extensively than formal balance or any of the other balance systems. It is more gratifying because it is more casual and more interesting. It is, however, harder for the designer to achieve and also asks more effort from the viewer.

9•10

Diagram depicting *informal balance.* A large shape and several smaller shapes suggest the same *visual weight* distributed equally.

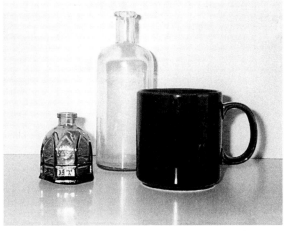

9•11

Asymmetrical balance is achieved in this design by the values, the transparency, and the size of the two objects with the cup, which is opaque, making it visually "heavier." *S. Brainard, Photo.*

9•12

Shirl Brainard, SPIRIT OF THE SIPAPU. 1989. Acrylic on masonite. 18″ × 24″. The elements in this painting have been distributed in order to achieve *informal balance.*

3. APPROXIMATE SYMMETRY. A third system, which is seldom mentioned in design texts but that I feel is important to know about, is **approximate symmetry.** This symmetry makes the distinct technical differentiation between exact SYMMETRY, or "mirror image," and that which is often *perceived* as formal balance and *is not*. The *visual weight appears identical*. I always feel someone is practicing a little deception—leading me to perceive the design as formal—yet I realize it is a kind of informal balance, or a mixture of the two. This approach can relax a design that calls for being somewhat formal because it does not require the exactness or the mirror imagery of a strictly formal system. Often you will notice that this balance system may be called formal or symmetrical in instances where the precise technical difference may not be important. I feel we should be aware of approximate symmetry and be able to use this system. A dying design may be saved by resorting to just this type of variance in order to achieve the maximum visual effect.

9•13

Rob Douglas's painting, INFINITE STILLNESS 1. Acrylic and raw pigment on panel, 49" × 60". *Courtesy of Nuart Gallery, 670 Canyon Road, Sante Fe, NM 87501.*

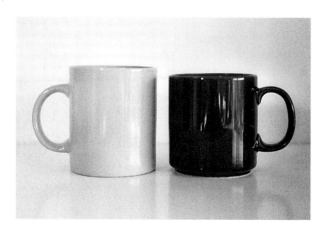

9•15

Two similar cups *appear* to be balanced symmetrically. Different values change the apparent visual weight, so they are considered to be in *approximate* symmetry. *Source: Shirl Brainard.*

9•14

Diagram: The shapes are the same but mirror-image reversed. Other shapes may be similar to one another but not the same. At first glance a viewer may "read" that they are the same. This illustrates *approximate symmetry.*

9·16

Gary S. Griffin, DOORS. Hand-wrought steel. 81″ H × 66″ W × 2½″ D. These doors have two sides that are very similar but are actually different. This design represents *approximate symmetry* balance. *Courtesy: Gary S. Griffin.*

9•17

Shirl Brainard, STORM. 2000. Mixed media collage.
16″ × 20″.

9•18

Diagram: *Radial balance.* Shapes are arranged around a
center or radius. The visual weight of the smaller
shapes is collective.

4. RADIAL BALANCE. The last balance system is **radial
balance.** This system uses a center or radius. The ele-
ments radiate from this center point and the *visual
weight* is distributed collectively, creating the feeling
of equilibrium.

9•19

VICTORIAN-STYLE GAZEBO. An architectural form based on *radial balance.*
S. Brainard, Photo.

9•20

L. Migdale, CIRCLE OF SMILING FACES. Circle of teen friends in Oakland, CA. Faces arranged in a circle balance one another by radiating from the center.

Photographer: Lawrence Migdale. Photo Researchers, Inc.

A POSSIBLE PROBLEM What happens when we take objects of identical imagery and place one each on each side of our space? Or place different images in each "corner" of our space? We may question whether we are using the space to the best advantage, for one thing. Would you put a different chair in each corner of your living room?

The visual response, again, is a mental division of the space into halves or quarters. The halves that are the same or appear to be the same (symmetrical or approximately symmetrical) can be soothing or boring, depending on the imagery and the function of the design.

The quarters of the room, however, tend to make us see four "squares," or a grid effect. The images lead the eye from one imaginary square to the next. Often this is acceptable and, in fact, is commonly used to unify diverse subjects, as we will examine later. It is

9•21

Dartboard. *Source: Getty Images, Inc.—Photodisc.*

9•22

LANTERN TOWER, Ely Cathedral, Cambridgeshire, England. This octagon tower is based on radial balance.
Source: Corbis/Bettman.

9•23

Would you put your living room sofa in the center of a room and a chair or table in each corner?

9•24

Diagram: Grid effect.

an automatic way to unify and balance elements, but its use must be chosen carefully. Simple, all-over patterns—using the repetition of a motif—are based on this balance concept. (We'll discuss "pattern" later.)

But would you use a grid in a room arrangement? Would you design a refrigerator with four equal spaces? What would happen if you designed a landscape painting in this way?

9•25

Oneida Silversmiths, Stainless steel tableware, Ridgecrest design. *Advertisement Courtesy: Oneida Ltd., Silversmiths. © Oneida Ltd. All rights reserved.*

◆ Let's Think About Space Division . . .

Why does the division of space affect BALANCE?

Are all designs divided within their space?

Are all the spaces equal?

When might it be possible to have a design divided in equal parts?

Can you see *where* and DIAGRAM *how* the design figure 9–25 is divided?

KEYWORD to remember: SPACE DIVISION–space is divided by POSITIVE and NEGATIVE SHAPES. (Don't forget that lines are positive.)

◆ Let's Think About Balance . . .

To create *balance:*

Do shapes have to be the same *kind* of shapes?

Do shapes have to be the same size?

Do shapes have to be the same value?

Do shapes have to have the same texture?

Do shapes have to be the same color?

Do shapes have to have the exact same visual weight?

What kind of balance would require all of the above?

Can lines be used in a design when you are trying to create balance?

Can shapes and other elements be manipulated to appear to have the same visual weight?

Now let's look at figure 9–26. This somewhat abstracted landscape uses a loosely defined vanishing point. The shadow of the pole serves to divide the wide space of the road. What would have happened to the BALANCE of the painting IF that shadow wasn't there?

Figures 9–27, 9–28 is a diagram of how to make some geometric shapes. Prepare some so we can do some "visual thinking" while we physically manipulate the shapes in a given space. You should have three to four values, from very light gray to black. For your spaces, use a sheet of white paper: 8″ × 10″ and 4″ × 5″.

◆ What Would Happen If . . .?

You used your largest black square and largest gray square on either side of an equally divided space on your small space?

Which appears heavier?

What happens if we turn the gray square?

What happens if the gray square were larger?

What happens if you turn the black square?

Keyword to remember: BALANCE—positive and negative shapes distributed in space by *visual* weight to create harmony.

◆ Ideas to Try Dividing Space

Use the following spaces, try and divide each space into three sections, using line.

Do you see you have broken up the space?

Think—the parts have become "shapes."

Think—are any of the divisions equal?

Could two parts, or sections, equal one part?

◆ What Would Happen If . . .?

You add a dark value to one shape?

You add two different values to two sections?

You add many lines to one section?

Is the balance affected?

◆ Ideas to Try for Balance

Using your cutout squares on the biggest paper, experiment with all four balance systems. First, use your space horizontally, then vertically; you will see that there *is* a difference.

Now try using some varied shapes on your smaller space. At first, try only the black squares. It will be easy

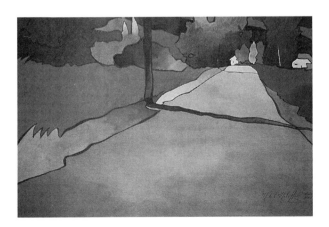

9·26

Mark E. Mehaffey, COUNTRY ROAD. Watercolor on paper, 21″ × 29″. Source: Mark E. Mehaffey. *Courtesy of Mark E. Mehaffey. Country Road, WC on paper, 21″ × 29″.*

9•27

Diagram: Geometric shapes for you to copy and use.

9·28

Spaces to work on.

to create all of the systems. Now try substituting gray values for your black squares. You have changed the value and, therefore, the weights visually. Try other squares of different sizes or textures, or add lines with a pen.
WHAT HAPPENS?

More Ideas to Try for Balance.

Grouping small shapes to counterbalance a large shape.

Grouping small shapes to counterbalance a dark shape.

Trying active textures with darker values, and lightly textured surfaces with lighter values.

Try using irregular shapes, which are usually more heavier than more easily recognized shapes.

Using a bright color to balance less bright colors of a larger mass.

Placing shapes above eye level to add visual weight.

Try placing lines close together. They will appear darker and can help counterbalance a dark-valued solid mass.

◆ Can You Identify . . .?

How is the space divided?

What element is used the most?

What kind of balance system is used?

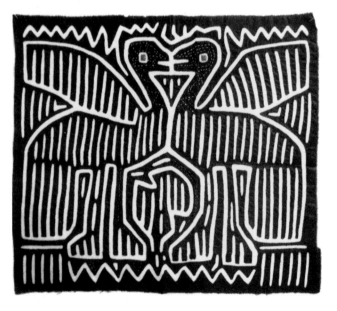

9◆29

Artist unknown, perhaps a child's work. MOLA. *Courtesy: Shirl Brainard.*

◆ Review

simple design ◆ Few elements used in the space and in the composition. Not difficult for a viewer to comprehend.

complex design ◆ Complicated as opposed to simple. Many elements used, so it is harder to design and comprehend.

implied axis ◆ A "mental" (or psychological) division of space. Usually centered or perceived bilaterally.

space division ◆ Space divided by the use of positive and negative shapes.

balance ◆ Positive and negative shapes distributed in space by apparent *visual* weight to create harmony.

symmetrical (formal) balance ◆ Technically, a mirror image: elements on either side of the implied axis having precisely the same shapes *but in reverse—* and having the identical same visual weight.

asymmetrical (informal) balance ◆ A balance system in which the visual weight on both sides of the implied axis of elements is equal. Elements often cross the axis.

approximate symmetry ◆ A balance system in which our first impression is that of symmetry. Weight may be identical but not a mirror image.

radial balance ◆ Created by repetitive equilibrium of elements radiating from a center point.

10
Unity

The principle of unification seems to be the most difficult principle to grasp. Balance is readily perceived, and we seem to notice more quickly when a design is not balanced. If a design lacks unity, however, it is more difficult to pinpoint WHY, because it is a more subtle problem.

Unification is the blending of flavors; it guides our eye and contributes to our reactions; it pulls the design together and makes us feel its wholeness or effectiveness.

I use the analogy of a party: A group of invited people with nothing in common, no theme, and no host or hostess present equals a very uncomfortable situation. The party needs at least *one* thing that everyone can relate to—one person (a host or hostess), an interest (music, food, a political figure), a theme (costume party, New Year's)—SOMETHING that enables each guest to say to someone else, "I am here for the same reason you are." This unifies the situation.

So let's define **unity** as the effect of having all the elements in harmony with one another, with each element being supportive to the total design.

There are three components or combinations which create unity: *REPETITION, VARIETY,* and *RHYTHM.*

Each of these components contributes to the unity of the composition. We will see how each can be used, and then how important it is that all are used together.

◆ Repetition

Repetition means "to use again."

In music we repeat a note or a theme that acts as a bridge to the time we heard the note before. This repetition unifies the structure of the musical composition.

In a design, we can repeat any of our elements.

We can repeat a shape.
We can repeat a line.

We can repeat a value.
We can repeat a texture.
We can repeat a color.
We can repeat the *size* of a shape or a line!

Repeating an element more than once is an important factor, but again we must plan carefully *how* we repeat and *what* we repeat. When we talked about balance, I mentioned the danger of having more than two images in a space visually dividing that space. At the other extreme, too much repetition of one image might also damage our design, *unless* we have a reason to create the effect of a "pattern," which we will discuss later.

Let's look at figure 10–1, which is a simple design. There are five black squares. Lines divide the rest of the negative space. There is formal balance. The negative spaces between the squares form rectangular shapes that are also repeated. The Large negative space at the top seems to counterbalance the heavier (due to value) shapes on the lower space. The shapes relate to one another because they are an exact repeat of each other.

◆ Variety

Variety, the second part of unity, means "to change the character" of an element. Variety provides the contrast that creates interest. But we have to be careful about variety also. If we have too much, it leads to confusion and we lose the interest factor. Any element can be made different, just as any element can be repeated. Some ways to vary our elements are the following:

Shapes can be varied . . . by kinds, sizes, colors, values, textures, location in the space, alternation, and the like.

Lines can be varied . . . by thickness, thinness, length, salves, straight, curved, and the like.

10◆1

Diagram: REPETITION. The space has been broken up by same-size geometric shapes and lines, using formal balance.

10◆2

Diagram: *Variety.* The sizes of the shapes have been altered. The balance is no longer formal. (Do you know what kind it is?)

Values can be varied . . . from dark to light.

Textures can be varied . . . from smooth to rough.

Colors can be varied . . . by their intrinsic nature.

Let's look at figure 10–2. NOW WHAT HAS HAPPENED?

In figure 10–2 we have added different values and sizes. The smaller squares are placed in such a way that they carry the eye from one shape to another. The up and down position contributes to a "beat" in the composition. We have created the last part of our unity: RHYTHM. Now look at figure 10–3.

◆ Rhythm

Rhythm means "a recurrence of movement." In music, the repetition and variety of notes create the rhythm that we remember, identify, and perhaps hum or whistle. In a visual work, RHYTHM is also created by repetition and variety. The way these two components are used gives us movement, both emotional and visual. As our eye travels around the design, we may experience an upbeat feeling, or we may be left with a more subdued sensation—one of calmness, sadness, or perhaps boredom.

The "visual path" our eye follows can be influenced by the *way* chosen elements are aligned or repeated. Windows repeated in a building may take our eye around and through the design, the same could be said for the repetition of a color in a room. The kinds of shapes used and how they are used together will decide the feeling we get from rhythm in a particular setting.

Look at 10–4. This photo of a swing "reads" as static. Why is this "play" object so quiet? Maybe it's naptime, a quiet afternoon. Or, maybe . . . what??

Let's now look at figure 10–5. How did your own feelings change as you looked at this? How does this "read"? There is a difference in the EMOTIONAL quality of the two photos.

10·3

Diagram: *Rhythm*. More variety and repetition and a more active way of positioning the shapes make the whole design more lively.

10·4

Swing. Chris Volk, Photo. *Source: SuperStock, Inc. Chris Volk/SuperStock.*

10·5

Child on swing. Photographer: Nancy Rica Schiff, Photo. *Source: SuperStock, Inc.*

Because this concept of mood, or "emotional quality or movement," is often hard to grasp, let's think about one more example. A penal institution should have good exterior and interior design. It needs to function in a specific way. Architecturally, it could

look decent, acceptable, BUT should it look welcoming? Should it be designed so that many of us would want to go in? Should the interior be so inviting and comfortable you would never want to leave? Churches, on the other hand, are designed to welcome, to enfold, and, once inside, to inspire exultation.

What about a sports car? A sports car's sleek, geometric shapes are aligned in long, tension-filled horizontals. It makes us think of sophistication, money!—speed! Other horizontal alignments, such as a landscape, may make us feel restful, peaceful, or even lazy. Landscape shapes will probably not be angular ones, as in the sports car, but soft, curved shapes undulating horizontally with little or no opposition.

Let's look at figure 10–6. This painting is an excellent example of BALANCE and UNITY using *repetition*, *variety*, and *rhythm*. It is an informal balance of

10·7

Diagram of *Captain of Industry*. *Source; Shirl Brainard.*

geometric and natural shapes. The two verticals on the left *balance* the vertical of the figure. The "joining" of those two verticals with the horizontal leading to the circular geometries creates a triangle which is *repeated* and *balances* the bend of the figure's arm resting on his hip. The circular shapes are *repeated* and there is a *variance* in the size as well as in the variety of the two kinds of shapes. The *rhythm* is created with the circular shapes moving (almost) around and around. One may almost hear a "hum" of factory noises. It makes a statement: "This is this man's job . . . however tedious."

Later, in SHAPE RELATIONSHIPS, we'll look at some "rhythmic devices" that can be of help to lead and carry the eye through a design.

◆ Let's Think About Unity . . .

Look at figure 10–8. WHAT HAS HAPPENED? WHAT HAS GONE WRONG? Let's think about what we have studied so far:

10·6

Joseph Lorusso, CAPTAIN OF INDUSTRY. Oil on panel. Repetition, variety, and rhythm create a unified painting. *Source: Joseph Lorusso.*

10•8

Diagram.

We have geometric shapes that are squares and triangles.

We have the darkest value as a background of the shapes.

We have a smooth texture as a surface quality of the shapes.

The more numerous small squares enhance balance by adding visual weight to counter balance the large triangles.

Shapes and sizes have been varied, but not too much.

It has REPETITION, VARIETY, and is RHYTHMIC.

WE HAVE DONE ALL THE THINGS WE HAVE TALKED ABOUT.

WHY DOESN'T IT LOOK GOOD? WHY DOESN'T IT WORK FOR US?

Keyword to remember: UNITY—wholeness

◆ Analysis

In figure 10–8, the space has been visually divided into two parts or halves by the exact repetition of the shapes. The two sides come close to balancing weight-wise, but the eye tends to look at EITHER the squares OR the triangles and not to "flow" through the space, taking in both at once.

◆ What Would Happen If . . .?

the values were changed?

lines were added?

rextures were added?

the negative spaces were considered more as "shapes"?

the triangles were located differently?

the squares were intermingled with the triangles?

10·9

Mortimer Menpes. FIVE STUDIES OF WHISTLER. Drypoint. *A. E. Gallatin Collection, Miriam and Ira D. Wallach Division of Art, Prints and Photographs, The New York Public Library, Astor, Lenor & Tilden Foundation.*

◆ An Idea to Try with Unity

Using your duplicate shapes, see if you can improve this composition. Try all of the above ideas. Which one, or combination, works best?

◆ A Design Analysis

Look at the drawing in figure 10–9.

What kinds of shapes are used?

What do these shapes portray?

Was line used as a contour line to create any shapes?

Was line used in any way that stands out to you?

Are a wide range of values used?

What do these values do to the shapes?

What kinds of textures are portrayed? Smooth? Shiny? Rough?

What kind of balance is used?

Why is this drawing unified?

Has the space been used well?

◆ Review

unity ◆ The effect of all the elements being in harmony with one another, creating the feeling of wholeness.

repetition ◆ The result of repeating or doing the same thing over and over.

variety ◆ The changing of the original character of any element; diversity.

rhythm ◆ A recurrence or movement. A "visual path" for the eye to follow; a "visual beat."

11
Emphasis

The last principle of design is the creation of emphasis. **Emphasis** is *what we want the viewer to see.* Emphasis is the visual destination of our design journey and should invoke a mental, emotional, or physical response. It is the designer's responsibility to direct the viewer's eye to this area. A quote from Robert Henri: "The eye should not be led where there is nothing to see."

The NAME of the product is an absolute necessity in the instance of a product to be sold. The name IS the emphasis or focal point. In the design of a building, emphasis is perhaps placed on the door, which may be more decorative than the rest of the building so people are drawn to enter there. In a painting, however, the emphasis may be on an *element* only, such as texture or color. Earlier, we discussed the intention of the designer. This emphasis only on an element is a prime example of the difference between functional design, which has content, message, or focal point for the viewer, and nonfunctional design, which considers the creative intention of the artist or designer whether or not there is a message.

◆ Contrast

Emphasis is created by CONTRAST. If you will remember, CONTRAST was discussed in the chapter on VALUE. It is seeing the difference between one thing compared to another. Some authors of design textbooks give many titles to the ways one might create emphasis, but it all comes down to contrasting one thing to another. It *does* matter how the contrasts are used, as it does with the other principles: One gray square contrasted with another square the same size but of a contrasting value will not create an emphasis. The eye will only go back and forth between them, unable to decide which is the more important. *Perhaps the entire message of the designer is "see the contrast of this square to this square."* But if we want the viewer to see more, we must make more defined contrasts.

The following are some contrasts that can create emphasis:

Contrast of position or location of an element to other elements.

Contrast of size of shapes to other shapes.

Contrast of size of a shape to the rest of the space.

Contrast of values to other values.

Contrast of shapes to lines.

Contrast of lines to values.

Contrast of textures to other textures.

11◆1

Stephen Quiller, AUTUMN ASPEN RHYTHM. Watercolor and gouache. 26″ × 20″. This painting emphasizes the abstract quality of the trees with line and geometric shapes. *Courtesy: Stephen Quiller.*

11◆2

Diagram: There is not enough contrast between the two squares for one to be seen more than the other. They tend to compete for attention.

Contrast of textures to values.

Contrasts between widths, lengths, kinds of line.

Contrast between colors.

Contrast of edges of shapes—torn to cut, and the like to other edges.

Contrast of the "anomaly" to the rest of the design.

◆ Any Contrast Can Be Made to Work! By the Way . . . What Is an Anomaly?

An **anomaly** is a deviation from the normal, or what is considered ordinary. If I go to the beach on a hot day dressed in a muffler, mittens, and winter coat, I am an "anomaly." People would notice me! We all, at one time or another, have felt we were "different" from others in a given circumstance or didn't "fit" into a situation. At that time, we were "anomalies"—or thought we were.

Anomalies very efficiently create emphasis by directing the eye quickly and surely to the area we want the eye to go.

Obviously, several elements can be combined in our effort to create emphasis: A textured area may have a defined color; a shape that is an anomaly to other shapes may also have a contrast of values; and so on. The ideas one can generate with contrasts are endless.

Little prints.
Warner Wallcoverings

Available through interior designers and decorating departments.

11·5

Warner Wallcoverings, Advertisement. The little shape in a big space makes the shape seem obvious. Because nothing else competes with the shape, the eye drops to the message. (Note how the little "tail" on the heart also directs the eye to the name.) *Courtesy: Warner Wallcoverings. Chicago.*

11·3

Diagram: The size of the shape contrasted with the size of the space makes you see the shape.

11·4

Diagram: The same idea–the contrast between size of space to shape. In this example, the shapes are larger than the space.

11•6

A 1993 advertisement for BIJAN perfume. The size contrast makes it impossible not to see the product advertised. *Courtesy: Bijan Fragrances, Inc.*

11•7

Diagram: The contrast of values indicates a focal point or emphasizes what the viewer is meant to see.

11•8

NOT A ONE HORSE TOWN (Chicago). The value contrasts—shadowed areas against sunlit areas—make one see the carriage and horse. *S. Brainard, Photo.*

11•9

Diagram: An *anomaly* is something "out of place." In this example, the circle is "out of place," so it is readily seen.

11•10

Advertisement for brushes. A paintbrush nestled in a bunch of asparagus is an *anomaly. Photography: Pat Berret. Permission granted by Daler Rowney, Cranbury, NJ.*

11◆11

Diagram: The contrast of position of one shape to other similar shapes creates emphasis. The eye interrupts its travel to look at that shape.

11◆12

Daniel D. Morrison, A SUNFLOWER FIELD. *Photo for Texas Department of Agriculture*

◆ Selection

Emphasis is often a matter of selection. Students (and professionals) often can't decide what they really want the viewer to see. This is especially true in drawing and painting. In designing, we want to direct the viewer's eye by using rhythm (to get the viewer on the visual path) and emphasis (to make the viewer stop and look). We must also pare down the nonessentials.

Once again using baking as our analogy, let's think about our chocolate cake. We already have a fine recipe for our cake, but then we decide to add some nuts. Good . . . they go well together. And how about a banana? Some raisins? Pineapple?

What is happening? The emphasis is no longer on a CHOCOLATE cake. It has become another kind of cake, and although we may have created an excellent new cake, the chocolate *essence*—or CHOCOLATE emphasis—has been diminished.

We must economize so as not to use more than what is needed for an excellent design.

Remember: LESS CAN BE MORE.

◆ Let's Think About Emphasis . . .

What might you emphasize when designing or decorating your living room?

What might you emphasize when designing a refrigerator?

What might you emphasize when designing a garden?

What might you emphasize when you are dressing (designing) yourself?

What do you think a chef might try to emphasize?

What do you think a choreographer might emphasize?

What does tying a yellow ribbon on a tree mean?

What are ways in which we might emphasize our house if we are having a party?

HOW MANY OF THE ABOVE ARE FOCAL POINTS?

Keyword to remember: EMPHASIS—*contrast*

◆ Ideas to Try for Emphasis or Focal Point

Go back to figure 10–12. WHAT WOULD HAPPEN IF you created a focal point? How could you do this?

Use your cutout, valued geometric shapes, or make some more. You might also consider adding line.

CAN YOU MOVE YOUR SHAPES AND LINES AROUND TO CREATE THE CONTRASTS WE TALKED ABOUT?

Did you create an ANOMALY?

Did you tend to use one kind of geometric shape more than any other?

Do you prefer that kind of shape?

Do you know why?

What could this tell you about yourself as a designer?

◆ Can You Identify . . .?

Which figure in figure 10–13 is the focal point? WHY?

Which SHAPE in figure 13–23 is the focal point? WHY?

◆ Review

emphasis ◆ The main element or focal point; what the viewer's eye should see first.

anomaly ◆ Something that is noticed because it differs from its environment.

12

Shape Relationships

◆ Safety Nets

The information we have just studied is essential to a design. Any effective design must include elements, and these elements must be arranged using these particular principles.

But sometimes that isn't enough. Sometimes we get stuck, or we look at our work and it doesn't seem to work. Sometimes we have a "dry period" and need a new direction. We may need a "safety net" or some "device" to help us out.

A **device** is not a design term. It is a word that means "a way" or, as *Random House Dictionary* cites, "a trick for effecting a purpose." This definition describes the following information, which I call "devices."

◆ Shape Relationships

It happens frequently in uneasy design (a design that starts with good ideas but doesn't feel satisfying) that the way our shapes relate to one another or to their space does not work. The devices that can help us the most to correct this are SCALE, PROPORTION,

PLACEMENT, and TENSION. We can use these selectively when we need them.

SCALE. Scale refers to the *size* of one shape compared to another or to the space it occupies. Look at the example in figure 12–1. Notice how size affects your reaction to this design.

PROPORTION. Proportion is the relative measurement or dimension of parts to the whole. It is common in drawing to use one part = X parts to get good proportional representation . One example of this is the adult figure. We usually use the length of the head as a measurement for the rest of the body: One head length equals eight body parts, or the whole body. Proportion and scale are often confused and sometimes used interchangeably. Let's look at some examples of good proportion and observe how proportioned shapes look with other shapes or spaces. In figure 12–4, example A is a well-proportioned house. Example B is not. Why? In example C, the house in the first example is shown with a tree. What is your conclusion? Example D shows the tree with a person. What is your conclusion?

12◆1

Two men holding a giant pen or pencil. An example of exaggerated scale. *Source: SuperStock, Inc.*

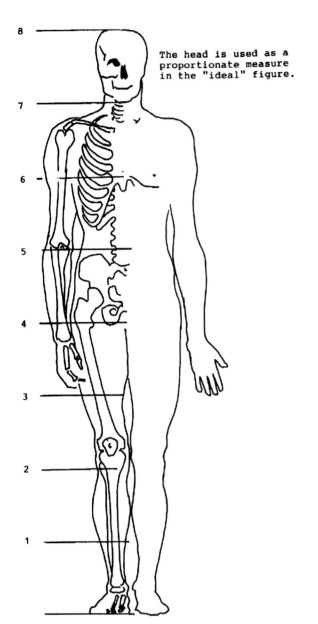

8

7

6

5

4

3

2

1

The head is used as a proportionate measure in the "ideal" figure.

"IDEAL" FIGURE PROPORTIONS

12•2

Diagram: Shows how the measurement of the head is used to draw an "ideally" proportioned figure.

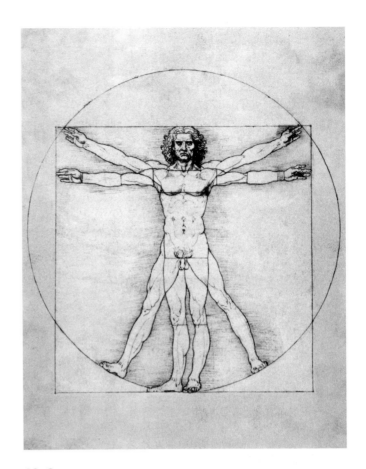

12•3

Leonardo da Vinci (1452–1519), PROPORTIONS OF THE HUMAN FIGURE. *Source: SuperStock, Inc. Galleria dell' Accademia, Venice/SuperStock.*

A B C D

12•4

Diagram.

Advertisement for custom-made sofas. A well-proportioned sofa in a well-proportioned room is still not compatible because of a difference in scale. *Courtesy: Century Furniture, Hickory, NC.*

If we change the size of our shapes, we can control the scale and proportion in our design. We can also create more interest because of the variance added to our design. This may be one of the first decisions we have to make, as in the case of refrigerator design. We not only need to have interesting variations in our size relationships of shapes (which can start with space division), but we must consider the actual inner-space usage. A freezer section and the cooling part of a refrigerator are not usually equal. We also have to consider the space into which some of our designs must fit and whether or not they will work in a utilitarian, as well as harmonious, way. Another reason for changing shape sizes is that we can control what the viewer sees in a believable way.

So we can say that changing the sizes of shapes can solve several design problems: scale, proportion, interest, space usage (actual or illusionary), or believable content.

SHAPE PLACEMENT. The **placement** or location of our shapes is important. We have all seen pictorial compositions in which some of the shapes just seem to float, not relating to each other or to the space, and

that end up boring the viewer. Let's see what happens when we place our shapes in a more thoughtful way.

In the first example (figure 12–6), the person appears to be the same size as the tree. If we change the shape sizes *and* OVERLAP the shapes (figure 12–7), what do we see now? The viewer either thinks the person is in front of the tree, or that the tree is farther behind the person, but that both the person and the tree are of normal size.

In figure 12–8, we see that several circles differ in size and overlap some of the other circles. In overlapping, some of the circles appear to be parts of other circles, but they are still seen as circles. Isn't this a more interesting design than figure 12–9, where the circles just exist in space?

Shapes that do not overlap or come close together are difficult to control. It's as though the space between them becomes boundless and the shapes are forever floating, which is nice if we want the feeling of being airborne. Otherwise, we need to anchor them through their relationships.

We spoke earlier of "visual" space division—when our eye perceives the space in quarters or halves because of the way shapes are placed and balanced. I

Diagram.

always use the word clump, indicating that our eye seems to move awkwardly (or "clump") from one shape to another. I think many students make the mistake "clumping" their shape because they sense the need for using the space but don't exactly know how. Many times—especially in two-dimensional pictorial designs—students will place their shape of interest in the middle of the space; then, because they instinctively feel a need to do more, they will put other shapes in

the "corners." Remember when we talked about this briefly in the chapter about space division and balance?

We can overlap one or more shapes; we can change the size of the shapes; we can move some closer together or even *almost* touch, or yes . . . **touch.** We can cluster or mass many small shapes together. In effect, we "count" them visually, and "weightwise" we "weigh" them as one shape. This is helpful in the principle of balance.

12•8

Diagram.

12•9

Diagram.

The way shapes FIT together is also important. Often when students try to vary their shapes, they create too much variety or create shapes that don't fit together well. If we look at figure 12–10, we see that these three shapes are different. They are geometric shapes. How do we make them work together or FIT together? We use the devices we have been speaking of: overlapping, touching, repositioning. Repositioning simply means playing with the shapes until they all look, feel, and work better together. Try them in different positions: upside down, sideways, half-concealed, cropped, from different views and different angles. An interesting "negative shape" may appear that the eye perceives as an actual shape in the design.

12•10

What would you do with these three shapes?

12•11

Nancy Kozikowski. U.S. SERIES #3. The use of "tension" in a design. Tapestry. 44″ × 30″. Look at how some of the "points" of triangular shapes fit into a curved negative shape. What does the "U" overlapping shape do for the design? *Copyright Nancy Kozikowski Design. Courtesy Dartmouth Street Gallery.*

Cropping. Another device we have already touched on briefly is that of **cropping,** or cutting off part of a shape. This happens automatically when we overlap shapes—the one in back is cropped. Fifty years ago cropping was not an acceptable idea in design, but then we didn't know many of the things about design we now do. Today we know that we can emphasize a shape *more* by cutting off part of it while still retaining its essence. In figure 12–13, part of the body is cropped, emphasizing the midtorso. It also serves to make the viewer *feel* that there is more space than can be seen.

12◆12

Diagram: A shape can become more important by "cropping" or cutting off a portion.

Tension. What is tension? **Tension** is OPPOSITION! We get a "tension headache" when someone opposes or goes against what we are doing, or not doing. Even TIME sometimes seems to work against us. Tension in certain compositions can create a liveliness, a vitality, excitement, or energy. Do you recall what I did with the squares when we discussed variety? To give variety to otherwise static squares, I positioned each square at a little angle to the next square. This relieved the monotony of having each square marching solidly across the line to the same beat: DUM—DUM—DUM. By adding a little tension, the squares seem to skip along, DUM—TE—DUM—TA! Tension creates rhythm and mood in a design and, in general, makes that design more arresting to the viewer. Zigzags, verticals, diagonals, and fan shapes are useful in composing upbeat paintings.

Tension is not a new design concept, but the term *Tension* is relatively new. It means a "push-pull" per-

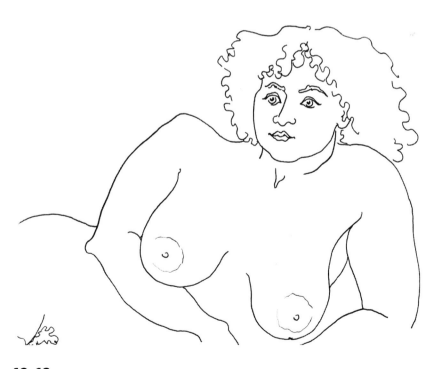

12◆13

Wesley Pulkka. ALICE. Ink drawing. *Source: Wesley Pulkka.*

12·14

The symbol for "yin-yang".

12·16

Diagram: Juxtaposing one shape against another creates *tension* or the sense of "push and pull" (or yin-yang). Different degrees of the angles determine how active a design can be.

12·15

Diagram: A triangle is an example of ready-made "tension" as each side opposes the other. Triangles generate energy and action in a design.

12·17

Mark Mehaffey. SOUTHERN EXPOSURE. Watercolor. 21″ × 29″. By intersecting diagonals, the design has become energized. *Courtesy: Mark Mehaffey.*

ception, created by elements that oppose one another slightly to greatly. Originally it was called "yin-yang," a principle in the Taoist philosophy founded by Lao-Tsu in China. It meant "opposing forces that bring about balance" (or harmony or unity), and it often stands for MALE/FEMALE.

Let's study a design using strong tension. Look at figure 12–18. This painting portrays active street life. Its shapes all oppose one another. Doesn't this say it's an accident about to happen? The composition also forms an upended "square" or shape for a visual path, which we will speak of shortly.

12•18

David FeBland. INTERSECTION. 1998. Oil on linen. 16″ × 20″. Can you "feel" the tension in this painting? Does it make you wonder if there will be an accident? *Source: David FeBland.*

Rhythmic Devices. The hints given you thus far will help with the placement of shapes and lines. As you move these elements around in your space, you will see that they may be arranged so as to create the "visual path," or rhythm, spoken of earlier.

12•19

A "visual path": some ways that elements can be arranged to guide the eye through space.

12•20

Diagram: Elements aligned as a "C."

12•21

J. Sohm. ALBUQUERQUE BALLOON FESTIVAL. The alignment of balloons creates a reversed "C". *Photographer: Joe Sohm/Chromasohm. Photo Researchers, NY.*

12•23

Gary Faigin, AMONG THE FALLING; DROP ZONE, 1995. Oil on canvas, 60″ × 30″. Gary Faigin. *Courtesy of Gary Faigin, Seattle Academy of Fine Art.*

12•22

Skip Lawrence. VIEW FROM THE STUDIO. 1995. Watercolor. 28″ × 40″. *Courtesy: Skip Lawrence.*

12·24

Mark Mehaffey, WHERE THE HAWK PREYS. 1985. Transparent watercolor. 26″ × 35″. *Courtesy: Mark E. Mehaffey, Williamston.*

12·25

Oneida Silversmiths. *Satin Edge* design. Stainless steel tableware. Advertisement. *Source: Oneida Ltd., Silversmiths. Oneida, Ltd. All rights reserved.*

T

12•26

Winslow Homer (American, 1836–1910), BLACKBOARD. 1877. Watercolor on wove paper. Laid down 19 3/4″ × 12 3/4″; framed 22 3/16″ × 18 3/4″. *Photographer: Dean Beasom. Gift (partial and promised) of JoAnn and Julian Ganz Jr. in honor of the 50th anniversary of the National Gallery of Art. Photograph © 2001 Board of Trustees, National Gallery of Art, Washington, DC.*

12•27

Gary Faigin, EXPULSION FROM PARADISE. 1996. Oil on canvas, 70″ ″× 40″. Objects are composed in an "L" shape. *Source: Gary Faigin. Courtesy of Gary Faigin, Seattle Academy of Fine Art.*

These are not mandatory arrangements, but *often* these alignments are apparent in advertisements, landscape design, fine art, and other designs. They are perceived as linear paths. Even though these alignments are very common, they are not readily recognized by the viewer, nor should they be. A person must be versed in their usage and be willing to look for them. We want to strive for that subtlety also if we choose to use them.

Look at figure 11–19. Does this design follow any of these visual paths? Which one?

Grids. There are two more devices available to us. Both are concerned with unification and the presentation of a design. The first is one of the most frequently used devices in the design field: the **grid**. A grid is a regular network of uniformly spaced horizontal and perpendicular lines. There are many varieties of the basic grid. Sometimes there are really no lines, but el-

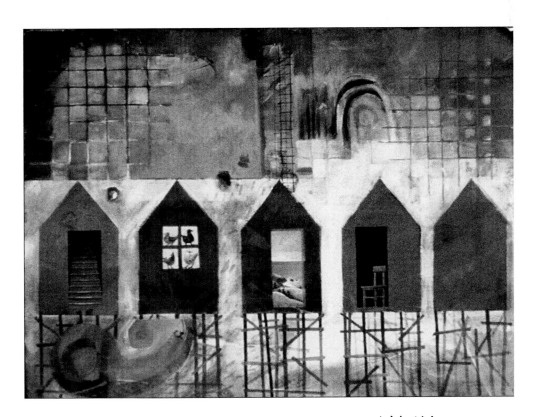

12•28

Michael Schlicting. LIFE'S CHOICES. Watercolor 22″ × 30″. *Source: Michael Schlicting.*

12·29

Diagram: Grid.

12·31

Craig Ruwe, SUNFLOWER STUDY. Vitreous enamel on board. *Source: Craig Ruwe.*

12·30

Advertisement for Oakwood Credit Union by Cuna and Affiliates. Madison, Wisconsin.

Source: CUNA Mutual Group and Affiliates.

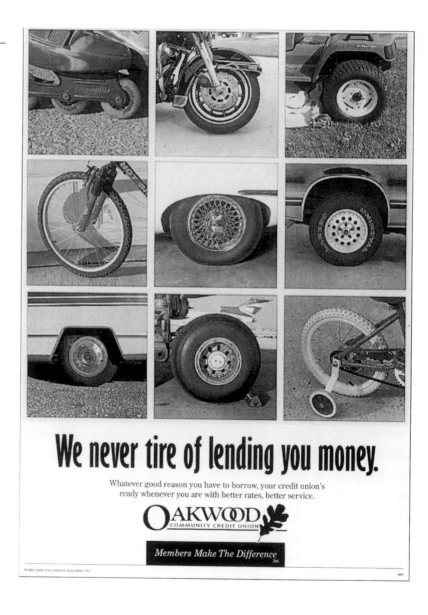

ements may be placed in such a way that the *implication* of space division is perceived.

Grids are extremely handy in unifying very diverse subject matter. As we mentioned in explaining UNIFICATION, repetition is a means of unifying—and a grid does just that. We are all familiar with designs based on the grid, but, like the element of LINE, they are so common that we don't stop to consider them for our own use.

Pattern. Pattern is a natural follow-up to grids. A grid is the repetition of squares in a regular sequence and could be accepted as a basic **pattern.** The simple, functional quilts stitched together by pioneer women to provide warm bed covers involved the piecing, or sewing together, of many squares of one size. These squares were not of the same fabric or color but a variety of both. Alteration of the exact grid effect came about because there were not enough scraps to make a new square identical to all the others, so smaller

12•34

Kazumi Yoshida, PETITE JAPONERIE, for Clarence House. Fabric design. *Courtesy: Clarence House.*

pieces were sewed together to make a square of the original size. These variations of sizes, and the interplay of shapes and colors, started some of our earliest traditional quilt patterns.

Pattern is repetition. A certain type of behavior—positive or negative—repeated over and over is called a "behavior pattern." In designing, we may contrive patterns as a way to establish variation, as well as movement or rhythm.

A shape, or a variation of that shape, used in an irregular way is called a **random pattern.**

These patterns exist everywhere, especially in nature. Look back at figure 8–12. The repetition of the

12•32

Quilt design based on common grid: same-size squares sewn together.

12•33

Smaller available pieces of fabric dictated changes in design. Some of our traditional quilt designs evolved from early piecing together of fabrics.

12•35

C. D. Winters, PETOSKY STONE. The varied repetition of similar shapes in an irregular way gives us a *random* pattern. *Photographer: Charles D. Winters. Photo Researchers.*

varied, but same-to-similar shape (the cottonwood leaf), in an irregular way creates a RANDOM PATTERN.

An **all-over pattern** is usually created by a **motif**. A motif is a distinctive recurring shape (or a combination of shapes). It is used in a planned or predictable way to make an all-over pattern.

The concept of the pattern, like the grid, can help us solve our design problem.

It can be structured as an approach to designing a painting. Figure 12–39 shows the space divided into three distinct areas by linear shapes. These areas are divided again by more linear shapes that sometimes make abstracted triangular shapes that are repeated also. The elephants are the major images (the emphasis), and they too are repeated but each in a somewhat different pose. Other images are repeated in predictable placement, like the flower and leaf shapes, the seed pods, and several less important, miscellaneous small shapes . Colors are also repeated, which you see as

12•36

A *motif.*

12•37

Wallpaper design. A motif repeated in a specific or predictable way creates an *all-over* pattern. *Courtesy: Warner Wallcoverings, Chicago.*

12•38

M. Borchi, Detail of Mosaic ruins in Oaxaca, Mitla, Mexico. A predictable pattern. *Photo by Massimo Borchi. Photo Researchers.*

12•39

Shirl Brainard, MAKING ELEPHANT TOOTHPICKS. 1996. Watercolor 20″ × 29″. *Source: S. Brainard.*

black to white values. The balance is approximate symmetry.

The various ways that we can use to strengthen our designs are, once more, a matter of CONTRAST. We often undermine the strength of contrast. We've talked about it in the chapter on value; we discussed it throughout the chapters on principles; and now we have seen that it is a factor in assembling our designs using some of the extra ways or devices. All contrasts are ways to compare, to show differences, to make the viewer SEE WHAT WE WANT HIM OR HER TO SEE!

◆ Ideas to Try

Use six of your cut-out, valued geometric shapes or make more. Again, remember line.

Manipulate your shapes and create a "working" relationship between the shapes.

Create a seventh shape as a negative shape.

Use more shapes. TRY:

overlapping shapes

touching shapes

almost touching

tension

DID YOU HAVE A PROBLEM WITH "TENSION?"

DID YOU END UP WITH ALL OF YOUR SHAPES DOING ALL OF THESE THINGS AT ONCE? WAS IT TOO MUCH?

◆ Now Try the Following . . .

Move your shapes around and create various RHYTHMIC PATHS.

Move your shapes around and create an UPBEAT mood.

Reassemble and create a quiet, tranquil mood.

Create a GRID. Can you make a grid with no lines?

Create a MOTIF. Create a PATTERN with your motif.

Create a pattern with simulated TEXTURE.

◆ Review

device ◆ A trick or way for effecting a purpose.

scale ◆ The size of one shape or image compared to another or to the space it occupies.

proportion ◆ The relative measurements or dimensions of parts or a portion of the whole.

placement ◆ Location, situation, or juxtaposition of elements.

touch ◆ To contact, adjoin.

crop ◆ To cut off a portion of a shape.

tension ◆ Opposing forces; push-pull, yin-yang.

rhythmic devices ◆ Systems of alignments in which to place elements to create a "visual path."

grid ◆ A network of usually straight lines placed at regular intervals.

pattern ◆ Repetition of a motif in either a predictable or random placement.

random pattern ◆ A pattern effect that is achieved through a repeated shape or motif that is scattered or not controlled. Less formal.

all-over pattern ◆ The pattern created when a shape or motif is used in a planned, predictable way.

motif ◆ A distinctive, recurring shape (or combination of shapes).

13

Analysis of Designs

- ◆ **A Design Analysis**
- ◆ **Defining the Principles**
- ◆ **Can You Do These . . . ?**

◆ A Design Analysis

We have asked ourselves questions about the elements and then about the principles of design. If we keep thinking about these elements and principles in this order, it enforces the information and helps us to clarify what we take in visually in a systematic way.

IN A GIVEN *SPACE* ARE PLACED *ELEMENTS*:

SHAPE
VALUE
LINE
TEXTURE
COLOR

ARRANGED USING THE *PRINCIPLES* OF:

SPACE DIVISION
BALANCE
UNIFICATION
EMPHASIS

TO GIVE US A *DESIGN*.
IF WE NEED HELP MAKING OUR PRINCIPLES WORK FOR US, WE HAVE SAFETY NETS OR *DESIGN "DEVICES"*:

SCALE
PROPORTION
PLACEMENT
CROPPING
TENSION
RHYTHMIC "DEVICES"
GRIDS
PATTERNS

Let us now look at a famous, representational painting: *Paris Street, Rainy Day* by Gustave Caillebotte,

13◆1

Gustave Caillebotte (French 1848–1894), PARIS STREET, RAINY DAY. 1876/1877. Oil on canvas. 212.2 × 276.2 cm. *Charles H. and Mary F. S. Worcester Collection 1964.336. © 1990 The Art Institute of Chicago. All rights reserved.*

and with our information, we can see how he was thinking as he composed the elements with the principles to create his design.

The FORMAT of the SPACE in *Paris Street, Rainy Day*, is HORIZONTAL. *Defining the elements:* The SHAPES are NATURAL (the figures) and GEOMETRIC (the buildings, the umbrellas, the paving stones, the cart and its wheels, and the lamppost). The geometric shapes form a background for the natural shapes, being "supportive" shapes and creating contrast to the "people-shapes."

The VALUES in the foreground, closest to us, are dark, especially on the figures. There are mid-values that contribute to the "weather" feeling—that of a rainy day. The values get lighter as the eye moves back in the space. The lightest value is the sky (a negative space). That same value comes down into the space in back of the figures and continues to the front edge of the space. This provides an entrance to the painting for the eye.

There is the strong LINE of the lamppost and its shadow, plus lines on the major buildings and the lines of the umbrella shafts. There is some indication of line in the paving stones.

The TEXTURAL quality of the paving stones looks slick, almost slippery. The coats appear of a rather rough or maybe "wooly" texture, while the buildings, because they are more distant, do not show much surface texture. Buildings rely more on descriptive shape than texture, but they do not look "soft." In our illustration, we see no COLOR, only the color translated into dark-light values.

◆ Defining the Principles

The space has a definite *division* with the lamppost. This is NOT, however, directly in the center of the space, but to one side. It has *asymmetrical balance*, with the buildings in the background, especially the large triangular one, balancing "value-wise" with the darker-valued two (and a half!) figures in the foreground.

The painting is *unified* by the *repetition* of the figures, the vertical lines, the umbrella shapes, and the dark-to-darker values of the figures. The figures also offer *variation*, by their different sizes and the directions in which they are walking. The umbrellas are also a variety of sizes. The *rhythm* is established by the visual path of the light values of the negative-space sky and the area behind the figures.

The eye does move from figure to figure, back and forth. The left-hand figures enter the lighter value and proceed toward the two closest figures. We see the light value "entry point," but there are two others: the line of the curb to the lower left of the post and the line at the bottom of the building (lower right).

Caillebotte wanted you to see the man holding the umbrella with the woman as the focal point or *emphasis*. They are the largest figures with the most visible value contrast and detail . . . and they are facing you, the viewer (as none of the other figures are!). In fact, the direction in which most of the figures are placed is important. We can hardly see which way the smaller ones are going, but many are walking *away* from the couple. But the two on the far left and the one closest to the couple, are all walking *toward* the couple, as is the man at lower right (cropped).

These are some of the "devices" employed. The *scale* of the figures to the buildings give one a feeling of belief . . . that the building, although large, IS in the background. We have shapes *touching, almost touching, overlapped*, and *cropped*. There is a slight *tension* in that the eye goes from front to back, back and forth, which is part of the rhythm of the painting. There is another VERY slight bit of tension in the tilt of the umbrella shafts and the umbrella in the right foreground.

CAN YOU TELL WHAT TIME OF YEAR IT IS?
ARE THE PEOPLE RELAXED OR FEELING HECTIC?
IS THE WEATHER COLD? WARM?
HOW DOES THIS PAINTING MAKE YOU FEEL?

This, then, is the way we can look at a design, critique it, analyze it, and learn from it.

Once you are comfortable applying this to different designs, you realize your eye is becoming trained to see these things. It becomes easier to look at contemporary works or applied design and see how these elements and principles are really used.

Then we know if the design is GOOD or EFFECTIVE design.

Then we can decide, finally, whether or not we personally like the design!

Now it's your turn to analyze a painting. Figure 13–2 is James McNeill Whistler's *Arrangement in Grey and Black*, commonly known as *Whistler's Mother*, a portrait of his mother done in 1871. The public and critics rejected it completely. It was "too simple"—a "side-view" hadn't been done in portraiture! Therefore, it was considered "avant-garde." Let's look at it.

What is the *format* of the space?

What kind of *shapes* are used?

Are there defined *lines*?

How many different simulated *textures* do you see?

Can you identify *how* the space is broken?

Can you identify *what balances* what?

What is *repeated*?

What is *varied*?

What kind of "emotional" *rhythm* is represented?

Was a *rhythmic device* or shape alignment used?

What is the focal point or *emphasis*?

Is anything *cropped*?

Is there any obvious *tension*? Where?

How do *you* feel about this painting?

Can you diagram the painting?

13·2

James Abbott McNeill Whistler, (American 1834–1903) ARRANGEMENT IN GREY AND BLACK NO. 1: THE ARTIST'S MOTHER. 1871. Oil on canvas, 56″ × 64″. *The Louvre Museum, Paris. Source: Art Resource/Reunion des Musees Nationaux RMN.*

◆ Can You Do These . . .?

If you want to test yourself, here are some figures in this book for you to analyze!

8–10 VALUES ON COLORS
8–13 WOOD/PAINTING

8–23 JAPANESE GARDENS
12–17 MAHAFFEY/PAINTING
12–26 HOMER/PAINTING
12–27 FAIGIN/PAINTING
12–28 SCHLICTING/PAINTING

14

Three-Dimensional Design

- ◆ **Three-Dimensional Design**
- ◆ **How Is It Different?**
- ◆ **How Is It the Same?**
- ◆ **Let's Think About 3-D Design . . .**
- ◆ **What Can You Do to Create a 3-D Design?**
- ◆ **Can You Identify . . .?**
- ◆ **Ideas to Try with 3-D Design**
- ◆ **Review**

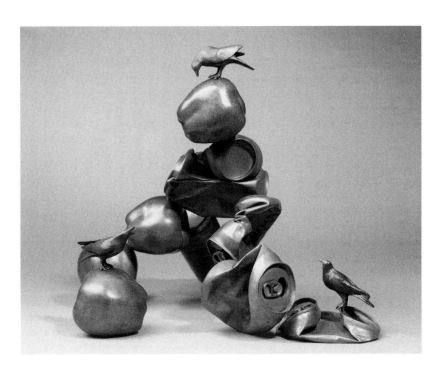

◆ Three-Dimensional Design

Throughout the book, we have seen references to **three-dimensional design,** or **3-D** design, as opposed to two-dimensional or 2-D design. In this chapter we will use the common abbreviations 3-D and 2-D as we examine the basics of 3-D design. How is it different from 2-D design? How is it similar?

◆ How Is It Different?

SPACE. First and foremost, 3-D design differs from 2-D design in the *occupation of space.* As we learned in Chapter 3, a 2-D design occupies a given length and width of space, whereas a 3-D design occupies not only length and width of a space but also DEPTH. In that same chapter it was mentioned, however, that a 3-D work could be designed on a 2-D surface.

You can only look at a 2-D work from the front or upside down and the images stay the same, even if they are perceived differently when upside down. It is still only width and length. It is possible, however, to walk around a 3-D piece or hold it in your hand and turn it

14◆1B

14◆1A-C

Bruce A. Niemi, ESSENCE OF DANCE IV. Stainless steel. Figures 14–A, B, and C gives us three views of the same figure. *Photographer: S. Brainard. Courtesy: Bruce A. Niemi.*

14◆1C

over and around; it may even surround you, like a building. The positive and negative shapes you see will seem to change.

Remember we talked about "designing ourselves"? When we dress, we are not flat, paper-doll figures. We have three dimensions. People can walk around us. We look different from various views. Think about the last time you had a haircut. Didn't the stylist turn you around as she or he cut your hair?

CONSTRUCTION. The second way the two differ is that in 2-D design a medium such as paint, graphite, paper, ink, thread, and so on is applied—spread on or printed on—by various means and *put on top of* a 2-D support surface such as canvas, paper, fabric or other surface. The result is still a two-dimensional, relatively flat piece.

In a 3-D design, the *basic* medium, such as wood, stone, or metal, is constructed, built, or *formed* by a number of diverse methods. Unlike 2-D design, it is necessary to at least introduce you to some methods used to create the 3-D design.

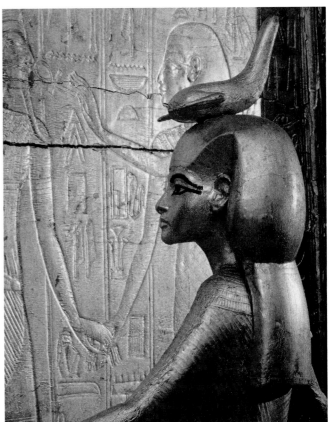

14·3

EGYPT, TUTANKHAMUN TREASURES. GODDESS OF SERKET. An example of sculpture "in the round" as well as low-relief work. *B. Brake, Photo. Photo Researchers, Inc.*

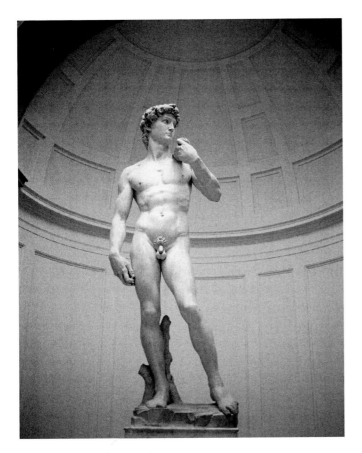

14·2

Michelangelo Buonarroti (1475–1564), DAVID. Galleria dell' Academia, Florence, Italy. *Gala/SuperStock, Inc.*

The first we identify with as children is the **subtractive method.** Remember taking a bar of Ivory soap in school or an activities program and making it into an "elephant"? You carved away chips and pieces. Of course, Michelangelo used the same method in his creation of *David* except that he used marble. This method of chipping away the basic material is one of the oldest in human history. The making of spear points or other tools by primitive man was "flintnapping," or flaking away the original material. The result is called "in-the-round" or "full-round."

Incising, or cutting into a material, was another subtractive or taking-away method. This is often called "low relief" (or bas-relief). Many times the depth was minimal. This was how early man decorated bone, ivory, and horn for decorative or ceremonial pieces. Another example is carving into the face of rock, called "petroglyphs." Or think of the "hieroglyphics" of the Egyptians, or other indigenous peoples. This has always been a popular and useful method, especially for smaller, decorative purposes.

14·4

Low relief on wooden spoons from Mexico. *S. Brainard, Photo.*

"High relief" is similar to low relief but the amount of depth is greater, often amounting to carvings that are half or more of the natural material's depth. High relief doesn't necessarily mean it was produced by the subtractive method. It could have been built up by some means.

Many of these high relief forms are created by carving, chiseling, or sculpting the solid material into another form. Thus, these forms are usually called "sculpture," or pieces having a "sculptured effect."

Sculpture as an art form of 3-D design is not confined to the subtractive method. The second method we should become familiar with is called the **additive method.** This is a method in which a work—whether an art form or architecture, or other, is created by the process of building up one or more materials. These materials may be "found" (materials originally not intended for the purpose now used) or "intrinsic," such as wood, clay, metal, fiber, and so on. Sometimes an inner skeleton or armature is made that supports heavier materials and helps give form to the projected work. A building can have an inner beam structure of wood or steel that serves the same purpose.

There are many other methods used to create a 3-D design. Think of common carpentry and the construction of a table or a building.

14·5

Shirl Brainard, TO LOUISE. An example of high-relief assemblage. *Pat Berret, Photo.*

14.6

George Manus PRAIRIE SCHOONER. 1993. 7'9" H × 10'3" W × 4'3" D. Illustrates "Found" materials. *S. Brainard, Photo. Courtesy: George Manus.*

14.7

GENEVIEVE THE SPOON BUG. Copper wire/silver-plated spoon.
Courtesy: Roger Evans. Pat Berret, Photo.

14•8

A work in progress, two horses: steel armature of one, and partly finished concrete figure of second. (Both to be titled.) 15′ L × 6′ W × 10′ H. *Courtesy: Roger Evans.*

Another perhaps familiar method is that of the potter: either hand-building or molding clay on a rotating potter's wheel. The piece is then fired in a special oven called a kiln.

14•9

The hands of Dan Feibig working on a pottery piece.
S. Brainard, Photo. Courtesy: Dan Feibig.

14•10

Mariana Roumell-Gasteyer, MAYBELINE THE HEN. Porcelain stoneware. 21″ × 16″ × 10″. *Courtesy: Mariana Roumell-Gasteyer. Margot Geist, Photo.*

We might also recognize the method of casting. A material such as silicone rubber is poured or brushed over a 3-D form, which has been made of clay, wood, stone, or other materials. Plaster is usually used as a cover over the rubber mold. After the plaster has set, the mold is removed from the original form. Another medium of liquid consistency is then poured into the mold. This may be a hot metal such as bronze, castable resins (plastics), or a "slip" (thinned clay). The result is a replica of the original but in a different medium. This method is also used for duplication.

Duane Hanson (American, b. 1923), SEATED ARTIST. 1971. Polyester resin and fiberglass polychromed (painted) in mixed media. Cast from a live model, this illusionistic figure is real looking.
Art © Estate of Duane Hanson/Licensed by VAGA, New York, NY.

There are other variations to all of these methods, but we will end the discussion here. We have looked at these methods to give us a better understanding of the complications of creating in the third dimension.

SIZE. Another difference between 2-D and 3-D design is that of size. As an extreme example, think of a postage stamp compared to a skyscraper. Obviously, this is not always true, but generally a 3-D work will be larger than a 2-D piece.

FORM. Speaking of size brings us to another difference—that of **form,** or density. A 3-D design's form has a sense of more weight, volume, or bulk, than a 2-D piece.

TEMPORARY SPACE. Lastly, there is another concept that we must not overlook: that of a three-dimensional space being occupied temporarily. This is the **temporary space** used for presentation . . . a political

debate, a performance of dance theater, or an exhibition. The occupants—shapes, either human or not—may be changing constantly, as in dance, or periodically, as in the articles displayed in a museum exhibit. Other examples could be the assemblage for a window display or an installation in an art gallery. The curator/choreographer/designer must give thought to the space in order to invite the viewer to explore and to react, but especially to give attention to the presentation.

Time is as important as perspective. How much time will it take for a viewer to look at, say, a kinetic (moving) sculpture? Will the viewer perceive it as the artist wished? Will the viewer watching a play witness the nuance of a scene in the short time the actors move about the set?

14◆12

Use of temporary space. Geneva Ballet Company, Switzerland. *SuperStock, Inc.*

SO FAR, SO GOOD... We have been introduced to the main differences between 3-D design and 2-D design. The one thing we must remember is that this other dimension, DEPTH, makes us stop and consider new things in our design.

Sometimes it's difficult to label a design as either 2-D or 3-D. A textured fabric wall hanging, a collage, or perhaps a low-relief carving may be considered 3-D because of its depth, which may be relatively shallow. Because it may have a flat back and because of the way a piece may be presented, it may be *viewed* as two-dimensional. There is often a very fine line between the two.

We have looked at many architectural and art forms in this discussion of 3-D design. In reality, there are probably more 3-D designs for consumer or industrial products. There are scooters, stoves, footwear, helmets, motorcycles, watches, light fixtures, chairs . . . everything around us, including the kitchen sink! They are all 3-D designs.

14·13

Man in hard had with computer screen. Examples of various 3-D designs. How many can you count? *Rob Bartee SuperStock, Inc.*

NATURAL AND GEOMETRIC SHAPES Peter Woytuk, CONSTRUCTION WITH SIX CANS AND FOUR APPLES, 2000. Bronze, edition of 30. 12″ H × 13″ W × 15″ D. Natural and geometric shapes are present in this sculpture.
Courtesy: Owings–Dewey Fine Art Sculpture Gallery, Santa Fe, NM.

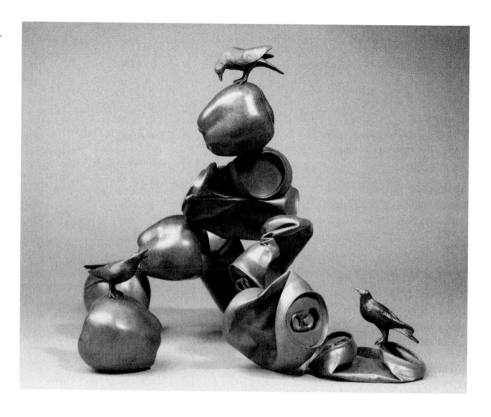

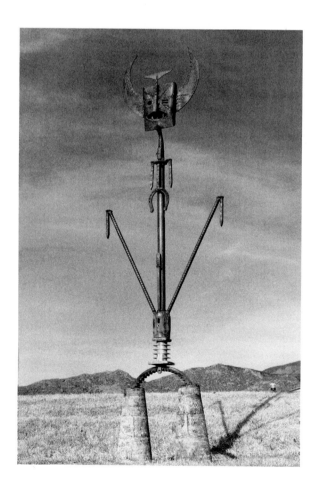

◆ How Is It the Same?

To quote sculptor Deborah Butterfield: "Sculpture (three-dimensional design) is just a different way of thinking from painting" (two-dimensional design).

As we look at examples of 3-D design, we can easily recall the *elements* of design. It's possible to identify all of the kinds of SHAPES, and we will see LINE.

Materials, as in 2-D design, may determine the TEXTURE and may play a part in the design itself. Light—natural or artificial—may affect how VALUE and/or COLOR may appear at different times or in different environments. We may want to refer back to figures 8–54, 8–55, and 8–56.

When we think of the *principles*, BALANCE is probably the most crucial. We need balanced build-

14•15

ABSTRACT SHAPE George Manus, ISCARIOT. Found media. 6′10″ × 18 1/2″ × 29″. Abstract shapes in sculpture. *Courtesy: George Manus.*

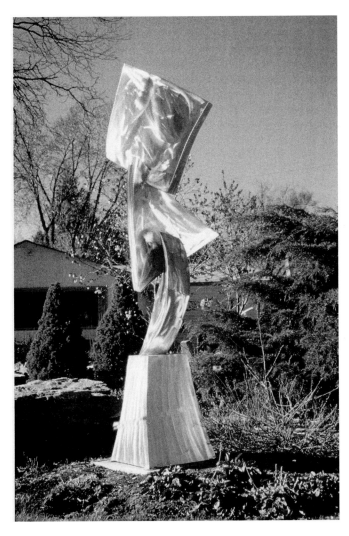

14◆16

Kevin Robb, TOY BLOCKS II. Sculpture—Stainless steel. 121″ × 40″ × 32″. This sculpture uses nonobjective shapes. Value is another important element, as it changes with different light or angles. *Courtesy: Kevin Robb.*

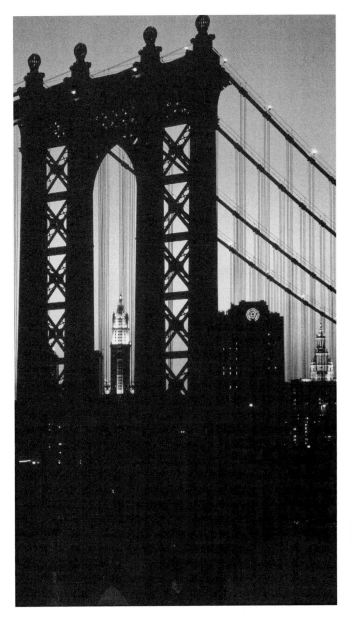

14◆17

NEW YORK MANHATTAN BRIDGE AT SUNSET. Line in 3-D design. *Courtesy: Photo Researchers, Inc. Ken Cavanaugh, Photo.*

Texture is the element and emphasis of this vase of wood. It also shows formal balance. *Pat Berret, Photo.*

14◆19

The principle of balance is shown in this desk and chair design by John Wesley Williams. Bird's Eye Maple Wood and Wenge. *Jim Osborn, Photo. Courtesy of John Wesley Williams.*

14·20

Sunset at the Lincoln Memorial in Washington, D.C., is an example of repetition, variety, and rhythm. The statue is obviously the emphasis or focal point.

Photograher: Joseph Sohm. Source Photo Researchers, Inc.

14·21

William S. Arms, THE PITCHER. 72" H × 66" W × 52" D. These painted steel 2-D pieces are joined to form 3-D life-size figures. Rhythm and excitement are evident. *On loan to Ted Turner Stadium, Atlanta, GA. Source: William S. Arms.*

ings, furniture, and autos, not only visually but also structurally.

The components of UNITY—repetition, variety, and rhythm—are present in most 3-D designs but are most obvious visually in architecture, auto, and furniture design. EMPHASIS may be seen readily in architecture as an entrance, but a handle on a door may be the focal point in a utilitarian design. A statue of a person standing alone presents itself as a strong focal point.

SCALE and PROPORTION need to be observed in the case of consumer design, but in a fine art sculpture they may be grossly exaggerated.

Our DEVICES often play a significant role in the 3-D design process. We will still think of SHAPE RELATIONSHIPS and their placement. TENSION (see figure 14.16) or a RHYTHMIC DEVICE (see figure 14–14) may be introduced. A repetition of windows or columns in a building may create a PATTERN (see figure 14–20).

We have now seen the similarities and the differences between 3-D and 2-D design. Yes, just another way of thinking.

Let's Think About 3-D Design . . .

Does format affect a 3-D design?

Would you use any division of space?

Could you use a 2-D space to design something in 3-D?

Does scale make a difference?

Can you use all of the balance systems?

Can you analyze any of the illustrations?

Keyword to remember: DEPTH—the added dimension with height and width.

What Can You Do to Create a 3-D Design?

Carve away material.

Add on material.

Make it BIG.

Make it SMALL.

WHAT ELSE?

Can You Identify . . .?

Which of the following are 2-D designs? Which are 3-D designs?

DOLL	TOMBSTONE	HANDKERCHIEF
PAPER CUP	ROAD MAP	WRAPPING PAPER
BOX	CEREAL BOWL	ALBUM/CD COVER
$1 BILL	BOOK COVER	PHOTOGRAPH
GLOBE	MURAL	A BEAD

Ideas to Try with 3-D Design

Try again with a bar of soap.

Use an empty box to create a fantasy 3-D interior (i.e., illustrate a scene in a book; or one of your own dreams).

Study one or several buildings. How many kinds of geometric shapes can you identify? Can you reconstruct this building two-dimensionally using shapes as in figure 10–16?

Can you analyze any of the 3-D illustrations using methods in Chapter 13?

AND SOMETHING TO REMEMBER—A CAKE IS THREE-DIMENSIONAL!

Review

three-dimensional (3-D) ◆ Having height, width, and DEPTH in a given space.

subtractive method ◆ A process of taking away original material, by various means, to give form.

additive method ◆ A process of building up or combining materials to give form.

Form ◆ The mass or volume—apparent density—of a 3-D work or the illusion of volume in a 2-D work.

temporary space ◆ Actual 3-D space used only for a defined length of time.

15

Problems & Solutions

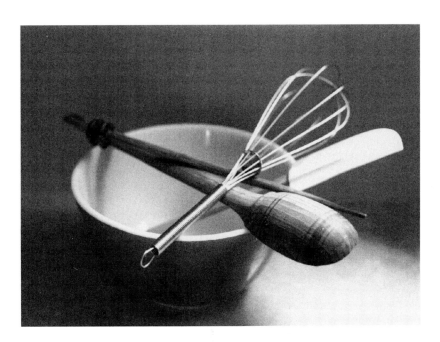

◆ Problem-Solving Procedure

We understand that a design is a solution to a problem. So far, we have looked at the elements and principles common to all designs. Now it is time to consider other things about designs.

Let's return to our cake. We want to make a cake. That is the problem to solve. What KIND of cake? What will it be made of? HOW will we make it? Let's start by looking at cake recipes. We choose one. We see the ingredients or materials needed. We decide whether we need to use a spoon, a mixer, or a food processor to mix it. Then we pop it in the oven!

What we have done is use a **problem-solving** procedure: DEFINED the problem; looked at our POSSIBILITIES or OPTIONS; DECIDED on a tool to mix it; and BAKED it.

We'll look at this process more closely. Then we will take a look at some of the materials and tools that can help us solve our design problems.

DEFINING THE PROBLEM. What *exactly* do you have to design? A refrigerator? A man's suit? A painting of a sunset? Different areas of design may have specific requirements. For example, the size of a car must be only so wide and so long to fit into existing garages and onto existing highways. Perhaps a requirement will arise because of a societal requirement for an article such as a gold-plated toothbrush. Perhaps only people with disabilities will use your product; maybe it is seasonal, or it may be regionally oriented for very specific utilitarian purposes (there are still *real* cowboys who really do wear cowboy boots!). A production cost factor may be a limitation. The list is endless, but so are the *possibilities*.

POSSIBILITIES. Any thought that may contribute to the solution of the problem should be jotted down and a sketch made. This is a brainstorming process that puts the initial idea into visual form. One idea may activate another, and the more ideas there are, the better the choices that can be made toward the solution. There may also be a mental incubation period, in which an idea is mulled over, thought about, and turned over. Haven't you ever faced a seemingly insoluble problem and suddenly awakened in the night with a plausible answer?

As we begin the selection or choice process toward a solution, we may have to do some research. Materials must be considered; cost factors may prohibit a marvelous idea; someone else may have already come up with your idea; individual interpretations of the problem may lose sight of the main objective. After all, just because *your* personal preference is to make a refrigerator look like an igloo doesn't mean that General Electric will agree.

PRODUCTION. After considering all the positive and negative information you have gathered, the choices begin to narrow and a clear view of the solution begins to emerge. If this occurs, you should probably put some of the better choices into more detailed thumbnails, layouts, or pasteups that you may present to your teacher, client, or employer for approval. On the other hand, if no approval is granted, this could be the time where the saying "back to the drawing board" originated!

15◆1A–D

Bob Kuhn, NORTH COUNTRY. Sketches. The problem of how to represent the bear as a wildlife portrait is being solved in this series of compositional sketches. *Courtesy: Bob Kuhn.*

15◆1B

(Continued)

15◆1C

15◆1D

FINALIZATION. This last step in problem solving comes when we finalize the choices we have made into a visual statement. We may have elaborated or minimized in order to define our solution. We have used our professional expertise to make decisions about the critical play of our elements and principles. We have remembered that the more focused the design, the more effective it will be to its audience. We have used our best technical abilities to present the design, and yet we have tried to maintain our own personal integrity and identity that becomes our style.

Problem-Solving Procedure.

> PROBLEM DEFINITION
> POSSIBILITIES
> PRODUCTION
> FINALIZATION

◆ Materials

As mentioned, your **materials** or media are what you use to make your design. Your present choice of media may not be what you'll use later. You wouldn't be the first to change design careers because of materials alone. I know an illustrator who was a landscape architect but liked doing the drawing better than the actual landscape project. I know a doll-maker turned potter and another architect turned sculptor.

The choice of materials may be based on your personal, physical, or aesthetic tendencies. Your choice

15◆2

Bob Kuhn, NORTH COUNTRY. Acrylic. 24″ × 36″. *Private collection. Courtesy: Bob Kuhn. Photograher: Kristine Kenner.*

will also influence the design itself. Common sense tells us that clay doesn't work as well as a pigmented medium to create a painting, but it does make a great bowl! Your aesthetics may make you choose fibers or fabrics over wood or steel because you like the feel of them better. Physical characteristics of materials may be what you like. You may want a medium that can be pounded, hammered, rolled, cut, folded, heated, cast, carved, bent, or twisted.

We may have to be concerned with a material's durability or longevity. We may have to ask if it will endure the weather. Will it rust? Will it be impervious to acid rain? What about climatic changes? Will it fade? Will it fall apart? These are a few of the questions to ask when choosing media.

We usually begin with materials on a two-dimensional surface, like coloring with crayons. We may then advance to various paints. We learn about different media; we experiment. This important exploration is paramount to our development as designers and is a never-ending journey.

◆ Tools

Earlier we spoke of how we were going to mix our cake. A spoon? A mixer? A food processor? Whatever we choose, one of these tools will help us mix our cake better than using our hands. Tools help solve problems. Every profession has its tools and each material may require different tools. The weaver, the bricklayer, the potter, the dentist, the carpenter, the chef—all have specific tools.

15◆3

Cake-Making Tools. Mixing bowl with whisk, spoon, and spatula balanced across the top. *S. Brainard, Photo.*

What is a tool? A **tool** is a contrivance, or something that can do work. A spoon is used to stir. A tool performs a function. Technology is ever in the process of giving us more sophisticated tools. Let's take a brief look at only two of the most used tools in the design field today.

CAMERA. The camera is a basic tool. It's a tool whose result is considered a medium: photography. Sometimes the two overlap. For example, as a tool a pencil is used for writing, but it is also a medium for drawing.

The camera has been used by artists as far back as da Vinci's time. Surprised? It was called a *camera obscura,* the forerunner of the old-fashioned box camera.

There are many types of cameras used by artists: video, digital, the common compact, and so on. A camera may be used to record our family's growth, docu-

15◆4

The camera: A handy tool for many chores. Man holding an old flash camera. *SuperStock, Inc.*

ment a crime scene or historical event, or create a visual catalog of information. Most conscientious artists keep a slide file of their work for portfolio presentation, juried exhibitions, and their individual business history. Many keep a print file of subject matter; some "still life" painters use photography as a means of "preserving" perishables, like fruit or flowers. Photography is used extensively as an advertising and illustration medium. Photography has become an art in itself.

The digital camera can do all of the above but uses no film, needs no developing, and stores the wanted images while deleting the rest. These images can be viewed on your computer or printed for use as posters, business cards, or even low-cost art prints.

The photographer Dorothea Lange said that "the camera is an instrument that teaches people how to see without a camera."

COMPUTER. We are still in the digital revolution! Did you know that it took 18 years before 50 million people tuned into radio compared to the *four* years that it took 50 million people to become computer users?

The computer is a versatile general-purpose machine with thousands of uses. It is an electronic apparatus that computes and stores information. It is, again, a tool and a medium at the same time. It is used in product and industrial design, the film industry, publishing, fine art—you name it, it can help you do it ! Robert S. McNamara said, "A computer does not substitute for judgment anymore than a pencil substitutes for literacy. But writing without a pencil is of no particular advantage." This quote sums up the help that digital techniques can offer, such as moving elements around in a given space in a two-dimensional design, giving the designer the options of viewing, making corrections, or deciding to begin anew. For an accurate representation of a three-dimensional object, be it a building or a sculpture, the computer can give us "virtual" views simultaneously of all sides of the object. This is different from a design composed on a two-dimensional surface, which is capable of showing us only *one* view (or side) at a time. Fed with pertinent information, the computer can calculate the dimensions of width, depth, and length and then enlarge the design. I personally imagine that the Egyptian pyramid builders would have loved them!

There are more and more software applications being developed for the design field. And we must not overlook computer-generated fine art. Here is an area that has taken two-dimensional art to a new boundary. Self-publishing artists can use digital printmaking to make a few prints or many. It is economical as well as space saving.

These tools have changed our perspective . . . and we have no idea what the limits are!

15·5

The computer can do magical things.
Computer with gloved hand and sparkles.
SuperStock, Inc.

15•6

A new image based on da Vinci's early work. Design based on Leonardo da Vinci's Proportions of the Human Figure. *Digital photo art by Jesse Ceballos. Galleria dell' Academia, Venice/SuperStock.*

◆ The Emergence of Style . . . and You!

As we ended the problem-solving sequence, I mentioned the designer's "style." I like to think that an artist's style evolves from several sources. One is the individual's trend of "personal choice" of, or leaning toward, certain elements or principles over others, as well as the individual's selection of materials. These choices often become our visual signature.

◆ Choice

I remember seeing a documentary on television about Buckminster Fuller, who designed buildings based on the triangle, as was the geodesic dome. When he was a child, he loved the shape of triangles; he drew them; cut them from paper and cardboard; made constructions of them; and in reality, finally built a designing career from them.

Perhaps your personal choice is red over blue. Maybe you like to maximize shape before line, and the like. It is whatever the artist is comfortable with.

It may happen that one device works exceptionally well for one artist and not at all for another; so, of course, it is to the advantage of the artist to use what he or she *knows* will be more successful. This does NOT mean that the artist is caught and cannot expand upon the chosen "system" that is working for him or her.

To quote our friend Robert Henri once more, he told students, "Find out what you really like, if you can. Find out what is really important to you. Then sing your song. . . ."

◆ Connections

Style emerges from how we look at our problem and HOW we go about solving it; HOW we interpret our solution in a creative way. Often, this may mean looking for our solution from a different angle in order to gain our desired effect. A measure of common sense, a little risk, willingness to explore possibilities, and a dose of playfulness are all assets that will help you pursue your style.

15◆7

Buckminister Fuller's geodesic dome in the U.S. Pavilion, Canadian EXPO 1967. *Bernard P. Wolff, Photography. Photo Researchers, Inc.*

15•8

Shirl Brainard, ROSE CONTAINERS. 2002. Watercolor/
paper collage. 18″ × 24″. *Private collection.*

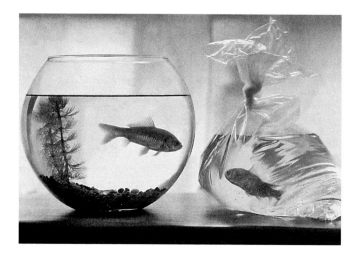

15•9

Goldfish in a plastic bag. *Laurence Dutton, Photo. Source: Getty Images, Inc.*

Here are some ideas and examples of how to start *connecting* ideas, by using different identifications, opposites, unexpected combinations, or similar associations:

This work (Figure 15.8) was for an art exhibition entitled "Containers." Defining "container" was the first step, followed by exploring the kinds of containers that may be fun to paint. The usual boxes, vases, or sacks were out. But an empty "Pepsi" can is *also* a container. What would one put in an empty drink can? What *wouldn't* one put in it? Roses? The idea was incongruous; it was great!

15•10

Shirl Brainard, DIANA. 2000. Mixed water media/
collage. 20″ × 24.″ *Source: S. Brainard.*

Obviously, pet goldfish (Figure 15.9) go in a "goldfish bowl" once they're home . . . but how do you transport a goldfish home? Another look at containers, even though this photo wasn't in the above art exhibit. But, think! HOW would you depict two goldfish looking at one another?

Figure 15–10 is a portrait of a fellow artist who does a lot of oriental calligraphy with her monotypes and often introduces the image of a raven into her work. The painting evolved from a sketch, later developed into the portrait after the association of her and the elements in the work she does. (See figure 15–11.)

"Creative license" is another way of connecting ideas. You've heard of someone taking "artistic" or "poetic license." It usually means taking liberties or deviating from an original written, audio, or visual work. Forms of humor, such as cartoons or parodies (Figure 15–12), are means of associating with an original idea without abusing the original.

15•11

Diana Stetson, RAVEN GIVES A JUMP. Monotype. *Source: Diana Stetson.*

A famous chef was interviewed about his culinary expertise, and one of his final statements concerned style, which, he said, "is like painting or music. You can take the same colors, the same ingredients and interpret them to reflect and express your personality."

So, you can add chocolate chips to your chocolate cake and that can be YOUR interpretation of CHOCOLATE CAKE!

◆ Passion

And last, but maybe the most important of all: PASSION. Your PASSION for your work! Your all-encompassing love for what you do! I will never forget hearing Gerald Brommer say in a workshop, "If you don't love what you're doing, quit bothering the paper!"

15•12

Shirl Brainard, WHISTLER'S MOM. (a.k.a. "The Big Bad Wolf.") *Source: S. Brainard.*

◆ Review

problem-solving ◆ A sequence of strategies for finding a solution to a problem.

Materials ◆ Media (singular: *medium*).

Tool ◆ A contrivance that can do work.

creative license ◆ Same as "artistic license"; the designer's choices interpret the problem's solution without abusing the original problem-solving requirements.

16

Conclusion

- ◆ **A Concluding Thought**
- ◆ **A Chocolate Cake Recipe!**

◆ A Concluding Thought

We have now concluded our conversational exploration of the fundamental concepts of design. You have gained some helpful ideas to fall back on for extra help, seen a way to use this information in order to analyze a design, and learned how to solve a design problem using a logical procedure. There are more ideas we could talk about, but these are the basics. These are the ones to master in the beginning.

The theory of design is just theory until you start your own exploration and experimentation with your own design problems. Experiments are practice, as are class projects, and all are learning experiences. Some will be good, and some will be terrible. NO DESIGNER is successful ALL of the time! And that is what designing is—continual, endless practice. Each new design is a fresh experiment—and each new solution, a revelation. It is exciting that you can use the same elements, the same principles, and even the same problems, yet the end result will always be different, the solutions endless, and the search a forever frustrating but rewarding experience.

We'll end with one more quote from our friend and teacher Robert Henri: "Keep a bad drawing (design) until by study you have found out why it is bad." THEN MOVE ON . . .!

HAPPY DESIGNING AND CAKE BAKING!

◆ A Chocolate Cake Recipe (Using "Creative License")

This is a delicious, moist chocolate cake, put together quickly without a single bowl to wash! It is economical, and perfect for today's health-conscious world, because it is almost FAT FREE! And, YES!, you really do need the vinegar . . . it sharpens the flavor.

Preheat oven to 375°.

Space: 9″ square baking pan (spray with nonstick cooking spray)

Elements (ingredients):

 1 cup sugar

 1½ cups flour (over *5,000°* altitude, add 1½ tablespoons more)

 1/3 cup cocoa

 1 teaspoon baking soda

 1/2 teaspoon salt

 2 teaspoons vanilla extract

 1/3 cup applesauce (the "creative license") OR 1/2 cup vegetable oil

 1/2 cup cold water

 2 tablespoons vinegar

Principles: (Method) Measure all ingredients, except vinegar, directly into cake pan. Mix all thoroughly, then add vinegar and stir quickly to blend. Immediately place in preheated oven. There must be no delay in baking after vinegar is added. Bake 20–25 minutes or until center puffs slightly and sides of cake begin to pull away from pan. Cool. May sprinkle top with powdered sugar.

Glossary

A

abstract shape A recognizable image that has been distorted or simplified.

actual space The real space we have to fill with our design. This space has defined dimensions.

additive color mixture The result of diffracted light reflected to our eye from a surface; color produced by light.

additive method A process of building up or combining materials to give form.

aesthetic A personal response to what we consider beautiful, often based on cultural or educated experience.

all-over pattern The pattern created when a shape or motif is used in a planned, predictable way.

analogous "Alike" hues; three to five (or more) hues lying next to one another on the color wheel.

anomaly Something that is noticed because it differs from its environment.

approximate symmetry A balance system in which our first impression is that of symmetry. Weight may be identical but not mirror image.

asymmetrical balance (Informal balance)—A balance system in which the visual weight of the elements on both sides of the implied axis is equal. Most often, the elements cross over the axis.

B

balance Positive and negative shapes distributed in space by apparent visual weight to create harmony.

boundary line A line that confines our visual attention. It may serve to separate areas.

C

color interaction The relative differences between colors as they react to one another in different environs.

color systems (Schemes, harmonies)—Synonymous with "simultaneous contrast."

color wheel A reference chart for colors.

complement The color directly opposite a selected color on the color wheel.

complex design Complicated as opposed to simple. Many elements are used so it is harder to design and comprehend.

composition The way the parts are arranged.

content The message created by the artist. May be functional for consumer purposes; iconography.

contour line A line depicting the outer edge of a shape or group of shapes.

contrast The result of comparing one thing to another and seeing the difference.

creative license Same as "artistic license"; the designer's choices interpret the problem's solution without abusing the original requirements.

crop To cut off a portion of a shape.

D

design A visual, creative solution to a functional or decorative problem.

device A tool, trick, or way used for effecting a purpose.

directional line A line or lines that direct our visual attention in a specific direction.

division space Breaking up space by use of positive and negative shapes.

E

elements The parts, or components, of a design.

emphasis The main element or focal point; what the viewer's eye should see first.

environmental design Functional designs considering natural surroundings.

F

form The mass or volume—apparent density—of a 3-D work or the illusion of volume in a 2-D work.

formal balance (Symmetrical balance)—Technically, a mirror image: Elements on either side of the implied axis have precisely the same shape, but in reverse, and have the same visual weight.

format The shape and direction of our working or actual space. May be horizontal, vertical, round, or the like.

functional design Design that is utilitarian; necessary.

G

geometric shape Usually man-made shapes that are precise, exact. Triangles, squares, circles, and the like.

graphic design Visual communication design for commercial purposes.

grid A network of usually straight lines placed at regular intervals.

H

hue A family of color; the pure state of a color.

I

implied axis A "mental," psychological division of space. Usually centered or perceived bilaterally.

implied line A perceived continuation of images or symbols that implies a line.

informal balance (Asymmetrical balance)—A balance system in which the visual weight of the elements on both sides of the implied axis is equal. Elements often cross the axis.

intensity The relative purity of a color; brightness or dullness.

intent What the designer or artist intended with the design; may not have content or message.

intermediate colors (Tertiary)—Colors produced by mixing a primary and secondary color.

L

line A mark longer than it is wide and seen because it differs in value, color, or texture from its background.

linear shape An elongated shape that reminds us of a line.

M

mass Having volume or depth; takes up three-dimensional space.

medium The kind of material(s) one is working with, such as pigments, film, fabric, pencil, steel, and the like (plural: media).

monochromatic One hue with value and/or intensity changes.

motif A distinctive, recurring shape (or combination of shapes).

N

natural shape Shapes found in nature; sometimes called organic.

negative shape The implied shape produced after two or more positive shapes are placed in a negative (empty) space.

negative space Completely empty actual or working space.

neutral The color resulting after two complements have been mixed to the point that neither color is evident.

nonfunctional design Design that is decorative or aesthetic. It is not strictly necessary for the functioning of a culture.

nonobjective shape A shape often made accidentally or invented from another source. There is no recognizable object involved.

O

original A primary, inventive form of producing an idea, method, performance, and so on.

P

pattern The repetition of a motif in either a predictable or random placement.

perception The individual response to the sensations of stimuli. Often cultural.

perspective The drawing technique of creating receding or diminishing objects of a three-dimensional nature on a two-dimensional surface.

pictorial space The illusion of depth or distance on a two-dimensional space.

placement Location, situation, or juxtaposition of elements.

positive shape A shape or line placed in a negative or empty space.

primary colors Colors that cannot be produced by mixing other colors. Theoretically, all other colors can be produced from the primaries.

principles Ways the parts or elements are used, arranged, or manipulated to create the composition of the design; how to use the parts.

problem solving A sequence of strategies for finding a solution to a problem.

product design The design of necessary, functional items in a society.

proportion The relative measurements or dimensions of parts or a portion of the whole.

R

radial balance Created by repetitive equilibrium of elements radiating from a center point.

random pattern A pattern effect because it is a repeated shape or motif but can be scattered or not controlled as in an all-over pattern. Less formal.

relativity The degree of comparison of one thing to another. How does *a* compare to *b*; then what is the comparison of *a* to *c?*

repetition The result of repeating or doing the same thing over and over.

rhythm A recurrence of movement. A "visual path" for the eye to follow; a "visual beat."

rhythmic devices Systems of alignments in which to place elements to create a "visual path."

S

scale The size of one shape or image compared to another or to the space it occupies.

secondary colors Colors produced by mixing two primaries.

shade A dark value of a color.

shape An image in space.

simultaneous color contrast Contrasting colors as defined by Michel-Eugène Chevreul using the traditional color wheel.

simple design Few elements used in the space and in the composition. Not difficult for a viewer to comprehend.

simulated texture The real quality of a tactile surface being copied or imitated.

space An empty, negative area where our design will fit.

space division Space divided by the use of positive and negative shapes.

split-complement Three hues; one hue and the hues on *either* side of its complement hue.

subtractive color mixture The result of pigments mixed together and exerting their force upon one another.

subtractive method A process of taking away material, by various means, to give form.

symbolic line A line or combination of lines that stands for, or reminds us of, something within our realm of knowledge.

symmetrical balance (Formal balance)—Technically a mirror image. Elements on either side of the implied axis have precisely the same shape, *but in reverse,* and have the same visual weight.

T

temperate colors The apparent psychological or emotional state of warmth or coolness of colors.

temporary space Actual 3-D space used only for a defined length of time.

tension Opposing forces, push-pull, yin-yang.

tertiary colors (Intermediate colors)—Colors produced by mixing a primary and a secondary color.

texture The quality of being tactile, or being able to *feel* a rough or smooth type of surface.

theory The examination of information that often ends in a plausible assumption or conclusion.

time and motion The planning for *actual* space to be used in bodily movement OR the anticipated illusion of movement in time.

three-dimensional (3-D) Having height, width, and DEPTH in a given space.

tint A light value of a color.

tones Neutrals of colors; relative neutral scale.

touch To contact, adjoin.

triad Three hues *equal* distance from one another on the color wheel.

U

unity The effect of all the principles being in harmony with one another, creating the feeling of wholeness.

V

value The range of possible lightness or darkness within a given medium.

variety The changing of the original character of any element; diversity.

W

working space The space that reflects the actual space. The two *may*, but not always, be the same space. This is the space we use to solve our design problem.

Further Research for Your Enjoyment

GENERAL

Robert Henri, *The Art Spirit*. New York: Harper & Row, 1984.

Rollo May, *The Courage to Create*. Des Plaines, IL: Bantam Books, 1975.

GENERAL DESIGN:

ID, The International Design Magazine. Cincinatti, OH: Faw Publications.

COLOR:

Jenny Balfour-Paul, *Indigo*. London: British Museum Press, 1998.

Victoria Finlay, *COLOR: A Natural History of the Palette*. New York: Ballantine 2002.

Simon Garfield, *Mauve*. London: W. W. Norton, 2001.

◆ **Some Interesting Websites:**

stevekline.com

jamesmcgulpin.com

mehaffeygallery.com

vebjorn-sand.com/thebridge.htm

satava.com

michaelschlicting.com

susanweeks.com

aletapippin.com

quillergallery.com

johnwesleywilliamfurniture.com

pantonecolor.com

unibz.it.com

Bibliography

◆ Chapters 1–12

Albers, Josef, *The Interaction of Colors* (New Haven, CT: Yale University Press, 1975).

Arnheim, Rudolph, *Art and Visual Perception* (Berkeley, CA: University of California Press, 1954).

Behrens, Roy R., *Design in the Visual Arts* (Englewood Cliffs, NJ: Prentice Hall, 1984).

Bevlin, Marjorie, *Design Through Discovery* (New York: Holt, Rinehart & Winston).

Birren, Faber, *Color and Human Response* (New York: Van Nostrand Reinhold, 1978).

——, *Creative Colors* (New York: Van Nostrand Reinhold, 1961).

——, *History of Color in Painting* (New York: Van Nostrand Reinhold, 1965).

Cheatham, Frank, Jane Cheatham, and Sheryl Haler, *Design Concepts and Application* (Englewood Cliffs, NJ: Prentice Hall, 1983).

Chevreul, M. E., *The Laws of Harmony and Contrast* (New York: Van Nostrand Reinhold, 1981).

Edwards, Betty, *Drawing on the Right Side of the Brain* (Boston: Houghton Mifflin, 1979).

Ellinger, Richard G., *Color Structure and Design* (New York: Van Nostrand Reinhold, 1980).

Elliot, Sheila and John Elliot, "Painting an Upbeat Mood," *The Artist's Magazine* (July 1986).

Itten, Joannes, *Design and Form* (New York: Van Nostrand Reinhold, 1975).

——, *Elements of Color* (New York: Van Nostrand Reinhold).

——, *The Art of Color* (New York: Van Nostrand Reinhold, 1973).

James, Jane H., *Perspective Drawing* (Englewood Cliffs, NJ: Prentice Hall, 1981).

Johnson, Mary Frisbee, *Visual Workouts* (Englewood Cliffs, NJ: Prentice Hall, 1983).

Lauer, David A., *Design Basics* (New York: Holt, Rinehart & Winston, 1985).

Leland, Nita, *Exploring Color* (Cincinnati, OH: North Light Publishers, 1985).

Mante, Harold, *Color Design in Photography* (New York: Van Nostrand Reinhold, 1978).

Mendelowitz, Daniel, *A Guide to Drawing* (New York: Holt, Rinehart & Winston, 1976).

Ocvirk, Bon, et al., *Art Fundamentals, Theory and Practice* (New York: W.C. Brown).

Osborn, Ray, *Light & Pigments: Color Principles for Artists* (New York: Harper & Row, 1980).

Pfeiffer, John E., "Cro-Magnon Hunters Were Really Us, Etc.," *Smithsonian* (October 1986).

Pile, John F., *Design Purpose, Form and Meaning* (New York: W. W. Norton, 1979).

Proctor, Richard M., *Principles of Patterns for Craftsmen and Designers* (New York: Van Nostrand Reinhold, 1969).

Sargeant, Walter, *The Enjoyment and Use of Color* (New York: Charles Scribner's Sons, 1923). Revised Edition (New York: Dover Publishing, 1964).

Shell, Ellen Ruppel, "With the Right Package, You Can Sell Anything," *Smithsonian* (April 1996) p. 54.

Spencer, Patricia W., "Roses Are Red, White, Yellow, Pink . . . ," *Natural History* (Englewood Cliffs, NJ: June–July 1976).

Sullivan, Louis H., "The Tall Office Building Artistically Considered," *Lippencott's* (March 1896).

Zelanski, Paul, *Color* (Englewood Cliffs, NJ: Prentice Hall, 1989).

Zelanski, P. & Mary Pat Fisher, *Design: Principles and Problems* (New York: Holt, Rinehart & Winston, 1984).

◆ Chapter 16

Coke, Van Deren, *The Painter and the Photograph* (Albuquerque, NM: University of New Mexico Press, 1965).

Leslie, Jacques, "Computer Visions, The Good, The Bad and the Unknown," *Modern Maturity* (November–December 1998).

McCormick, Tracy, "What's Hot," *U.S. Art Gallery* (November 2000).

◆ Miscellaneous

Baker, Kenneth, "Museum or Monument," *Connoisseur* (February 1988), p. 128.

Doherty, M. Steven, *Dynamic Still Lifes in Watercolor* (New York: Watson Guptill, 1983), p. 23.

"Expo," "Risky Biscuits." *ID, The International Design Magazine* (April 2004), p. 27.

Fichner-Rathus, Lois, *Understanding Art* (Englewood Cliffs, NJ: Prentice Hall, 1986).

Fischl, Eric with Jerry Saltz, ed., *Sketchbook with Voices* (New York: Alfred van der Marck Editions, 1986), p. 28.

Henri, Robert, *The Art Spirit*, compiled by Margery A. Ryerson (New York: Harper & Row, Icon Editions, 1984).

Hines, Jack, "Creative Process," *Southwest Art* (April 1996), p. 44; (May 1996), p. 42.

Jones, Ronald, "Breuer Beyond Bauhaus," *ID, International Design Magazine* (April 2004), p. 88.

May, Rollo, *The Courage to Create* (New York: W. W. Norton, 1975).

Merriam-Webster, Inc. *Dictionary of Quotations* (Springfield, MA: Merriam-Webster, 1992).

Merriam-Webster, Inc. *Thesaurus*.

Norman, Donald A., *The Psychology of Everyday Things* (New York: Basic Books, 1988).

Pfeiffer, John E., *The Creative Explosion: An Inquiry into the Origins of Art and Religion* (New York: Harper & Row, 1982).

Pleshette, Ann, "A Chef's Chef," *Food and Wine* (July 1982).

Samulson, Jerry and Jack Stoops, *Design Dialogue* (Worcester, MA: Davis, 1983).

Scanlon, Jessie, "Big Business," *ID, The International Design Magazine* (April 2004), p. 61.

Sides, Dorothy Smith, *Decorative Art of the Southwest Indians* (New York: Dover, 1961).

Sinclair, Cameron, "Speak No Drivel," *ID, The International Design Magazine* (April 2004), p. 33.

Underhill, Ruth, *Pueblo Crafts* (Washington, DC: U.S. Department of the Interior, 1944).

Index*

*Page numbers in italics refer to illustrations

C

Caillebotte, Gustave, *118*, 118–19
Calatrava, Santiago, 14, *14*
Cameras, *138*, 138–39
Carnes, Cindy, 57
Casting, 127
Cavanaugh, Ken, *131*
Ceballos, Jesse, *140*
Chagall, Marc, 55
Chaplin, James, *59, 64*
Chevreul, Michel-Eugène, 55, 57–58
Chocolate cake recipe, 146
Chromosohm, J. Sohm, *133*
Collage, 38, *38*
Color, 42–70. *See also* Design analysis
 overview, 42–45
 in three-dimensional deigns, 67, 68, 69
 uses for, 66
Color contrasts, 55–65
 complementary, 58–60
 monochromatic, 60–61
 split-complement, 60
 triad, 62–64
Color identity, 46–52
 color temperature and, *51*, 51–52
 hues and, 46–47, *47*
 intensity and, 57–58
 value and, 47, *47*
Color interaction, 52–54, *53, 54, 55*
Color perception, 52
Color purity, 48
Color temperature, *51*, 51–52
Color wheels, 42, 45–46, *46*
Complement, 48
Complementary:
 color charts, 58, *59*
 color contrasts, *58*, 58–60, *59*
Composition, 2
Computers, 139, *139*
Cones, *44*, 45
Content, design, 8
Contour lines, 20
Contrasts:
 color, 55–65, *55–69*
 emphasis and, 92–97
 shape, *93, 97*
 size, 92, *94*
 value, 33, *95*
Cool colors, 51–52, *53, 54*
Cropping, 105, *105. See also* Design analysis

D

Dark/light color contrast, 55, *56*
Delacroix, Eugène, 9
Depth:
 in three-dimensional design, 122–23
 value and, 33, *33, 34*
Design:
 defined, 2
 elements, 2
 environmental, 6
 functional, 6
 graphic, 6
 nonfunctional, 7–8
 principles, 2
 theory, 2–3
Design analysis, *118*, 118–20
Designers:
 each individual as, 9–10
 role of, 8–10
Device, 100
Directional lines, 21, *21*
Distance, value and, 33, *34*
Douglas, Rob, 76
Draper, Lincoln, *15*
Drawing on the Right Side of the Brain (Edwards), 28
Dutton, Lawrence, *142*

E

Eaton, Pauline, *56*
Ede, Jim, *72*
Edwards, Betty, 28
Elements of design, 2. *See also* Design analysis;
 specific elements
Emphasis, 92–98. *See also* Design analysis
 contrast and, *92*, 92–97, *93, 94, 95, 96, 97*
 selection and, 98
Environmental design, 6, 7, *8, 9*
Evans, Roger, *8, 126*
External pigmentation, 44

F

Fagin, Gary, *108, 111*

W

Y